pure design

mario garcia
pure design

79 SIMPLE SOLUTIONS FOR MAGAZINES,
BOOKS, NEWSPAPERS, AND WEBSITES

MILLER MEDIA
ST. PETERSBURG, FLORIDA, USA

Published by
Miller Media
St. Petersburg, Florida

Dedicated to the memory of my father,
whose passion for his craft inspired my own.

Special thanks to Dr. Pegie Stark Adam, Rodrigo Fino,
Mario Garcia, Jr., Ed Hashey, Mignon Kagnie, Aaron Kenedi,
Jan Kny, Theresa Kral, Elena Lazaro, John Miller,
Robert Newman, Ron Reason, Paula Ripoll, and Robyn Spoto.

Cover and interior design by Miller Media
Research by Robyn Spoto and Elena Lazaro
Copy editing and proofreading by Mimi Kusch
Front cover photograph courtesy of GettyOne Images
Aesop fable image courtesy of Mr. Agustin Edwards

Library of Congress CIP

ISBN 0-9724696-0-5

Printed in Spain
10 9 8 7 6 5 4 3 2 1

More praise for Mario Garcia and *Pure Design*

"Mario understands how writing, editing and design are inextricably linked, and how design at its best can help make great journalism even better."

—JOANNE LIPMAN
DEPUTY MANAGING EDITOR
THE *WALL STREET JOURNAL*

"If journalism was a garden, Mario Garcia would be the gardener, the one who figured out how to clear away the underbrush so the prize daisy could dazzle the reader. Some people design news pages; Mario defines them. *Pure Design* is clear, uncluttered and compelling—just like Mario Garcia."

—JIM NAUGHTON
PRESIDENT, THE POYNTER INSTITUTE

"I have no doubt that [*Pure Design*] will be immediately embraced by media design professionals and will become a standard reference on every bookshelf at every major daily newspaper and magazine in the country, and become a standard throughout the world."

—EDWARD JAY FRIEDLANDER
PROFESSOR AND DIRECTOR, SCHOOL OF MASS COMMUNICATIONS
UNIVERSITY OF SOUTH FLORIDA

"So absolutely relevant and it will not age. These [ideas] are tried and true and will always work no matter what you are working on. . . . I am so impressed with the way this book is written and designed. Very easy to read and travel through because of the clean design and the way it is written."

—PEGIE STARK ADAM
SYRACUSE UNIVERSITY

Cy commence le tiers liure des sub
tiles fables desope.
La premiere fait mention du pasteur
et du lyon.

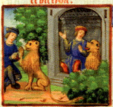

es puissās
ne doiuēt
point clere mēts
des biēfices receu
par culx des priuez
ne doyuent point
oblier de les remu
nerer Ainsi que
nous premiere ceste
fable dung lyon
qui couroit apres vne leste et en courāt luy
entra dedans le pie vne grosse espine laquelle
le blessoit grandement tant quil ne pouoit che
miner et sen vint a vng pasteur qui gardoit
les brebis et lecōmenca a flater de la queue en luy
monstrant son pie qui estoit naure. Lors le pa
steur eut grant paour et luy getta vne brebis
mais le lyon ne luy demandoit pas a menger
car il ne demandoit quester quen deson pie.
Apres le pasteur congneut la blessure et a
uec vne aguille luy tira lespine hors de son
pie et en getta la pourriture et tantost il fust
guery et pour rendre grace et remercier le paste
il luy baisa les mains et puis sen retourna en
la forest. Vng pru de temps apres le lyon
fut prins en la forest et fust mene a romme
et mis auec toutes les autres bestes pour auoir

Last year, I was lucky enough to be in Chile, as a guest of Mr. Agustin Edwards, the publisher of El Mercurio. *At one point, Mr. Edwards took me into his magnificent library to show me several rare books, among which was an illuminated manuscript, circa 1495, of* Aesop's Fables. *In addition to admiring the Gothic-style lettering and the sixty-six miniature illustrations drawn in liquid gold, I recognized instantly the author's ability to tell a complete story in just a few lines. Aesop was a precursor of the Internet, I thought. One does not need to "scroll" to read an entire fable. What a utilitarian and "modern" way to present valuable information. The inspiration for the short "fables" in this book was born there.*

—DR. MARIO GARCIA
SEPTEMBER 1, 2002

contents

color

pictures

process

foreword

JOHN MILLER

If I had designed 450 newspapers and been called the most impor-
tant newspaper designer in the world, I'd be tempted to rest on my
laurels. Not Mario Garcia.

The architect behind some of the most successful redesigns in the
world, including the *Wall Street Journal* (U.S., Europe, and Asia),
Die Zeit (Germany), *El Mercurio* (Chile), *El Tiempo* (Colombia),
Liberation (France), and the *San Jose Mercury News,* Mario Garcia
continues to be a visionary leader in the world of publication design.
For the last thirty years, he has championed ideas about readability,
storytelling, and multiple points of entry and has helped define how
content is presented in all media with one fundamental goal: always
design with the reader in mind.

But today readers have changed. People are inundated from so many
different directions they don't have the time to make sense of it all.
They flip, they scan, and they surf. All at the same time. Scarborough
Research recently reported that 91 percent of Internet users with a
TV in the same room surfed and watched television simultaneously!
(We usually blame the Web for this, but it probably should fall on
remote controls, the device with which people began seriously deter-
mining whether or not they were interested in a television station—
within five seconds.)

Editors and designers have responded by cramming in more and more and more and more, cranking up the volume in a cacophony of grueling, information-dense pages and mesmerizing, whirring screens.

But Mario's response is a new kind of design: clean, elegant, usable, and true to itself. Design that stands out from the clutter by presenting information in a radically simple, stripped-down way. In a word, *pure*.

Pure design is not a revolutionary concept. In fact, its basic "less is more" principles apply to all forms of design. Mario's series of design solutions presented here will give designers new perspective, help them decide what information is most important, and provide successful ways to present it.

Mario's ideas on pure design have been immensely helpful to my team and are the reason for my involvement in this book. We've been privileged to work alongside him and have seen the effectiveness of pure design in action. Today, this philosophy affects all of my work.

During a recent magazine redesign, we finished the look and feel of the pages quickly but went through round after round of designs for the information graphics, a key element in the new style. With each successive revision, we peeled off another layer of unnecessary information. It was a lot of work, but in the end we were left with

something brilliant: designs that were clean, simple, and instantly accessible.

For decades, designers have looked to Mario Garcia for inspiration, direction, and new thinking. In today's information-riddled world, the idea of pure design makes more sense than ever. ∎

introduction

MARIO GARCIA

Pure design is just what it sounds like—creating storytelling structures that are simple and uncomplicated.

Whether you are designing for a newspaper, magazine, website, CD cover, newsletter, or annual report, the inspiration for pure design comes first and foremost from the content to be presented.

Once that has been established, pure design calls for what I refer to as "look and feel" that is appropriate to the content and audience for which it is intended.

After years of print design developing as a means to adapt to rapidly growing technology, today design is starting to relax a bit, sort of what happened in the late 1960s, when the so-called minimal artists who emerged in that era insisted on stressing a certain architectural precision, which led to clarity and a nonrelational organization of parts. Indeed, it was a style of expression stripped of decoration and excesses. As minimalist artist Frank Stella famously said of his painting, "What you see is what you see."

For the visual journalist—those of us dealing with very specific content aimed at chronicling a story—the motto could be "what you see is how it is."

My idea of pure design is inspired by minimalism. And, although this movement found its truest manifestations in sculpture— composed of modular units, aluminum and steel cubes, and so on— one can relate to how artists of this group created, for example, horizontal sculptures made of identical units. The overall impression, however, is what contributed to "telling the story."

Likewise, pure design is a series of repetitions: how story structures are created, how a grid is adhered to, with the same number of columns and equal repetitions of white space, for example, with a typographic cluster that is identical, and, if possible, based on one family of type. All of this is ultimately highlighted by a color palette, again, made up of similarly hued colors, and only a few, which are constantly repeated.

To the minimalist artist, repetition of forms gave way to a grand overall impression. The same is true for those of us who adhere to pure design for telling stories in print and on the Web.

The segments that follow attempt to make clarity and simplicity foundations for all we do as designers. If the story is told with clarity and simplicity, then indeed, "what you see is the story." That, after all, is the most important part of our job. However, in our work, clarity and simplicity rely more on the designer's instinct than on theory.

Design theories

A graduate student from an American university recently wrote seeking assistance with her doctoral dissertation. "I am trying to establish some theories of newspaper design," she explained.

My response was that there are no "theories" of newspaper design, at least not in the abstract sense of the word. Newspaper design is deeply rooted in practical realities and is more an organic than an abstract theoretical process.

The most I could offer were some generalizations about what to do with visual journalism:

- Make it easy to read—use typography that is clear, easy on the eyes, and very legible.

- Make it easy to find—employ navigational tools that allow the reader to get to the content he or she wishes to read in the least amount of time possible.

- Make it visually appealing—provide an environment in which good content will find attractive display, thus increasing the number of readers who will use it.

Pure design is all about paving the way for readers to move through a publication or website almost effortlessly, while enjoying the experience.

Achieving design balance

How we achieve this level of design varies from medium to medium, since factors such as size, format, and time spent make a difference. For practical purposes, let us examine how pure design applies to a well-designed newspaper, knowing that its applications to magazine and Web design almost parallel. A well-designed newspaper must have:

- Newsy and appealing front pages.

- At least three powerful stories (high on emotion, low on baggage).

- At least one wonderful photo that conveys it all in ten seconds.

- A list of what I must *know* I'll find in the paper today.

- A very short list of what I *should* know if I have an extra five minutes.

- Something to make me feel good about *me*.

Good indexing

An index has always been an important part of a good newspaper. However, the emergence of the Internet, and the fact that so many newspaper readers browse websites, where navigation is a key element, has made it even more important for the modern newspaper.

Legible typography

A newspaper is, after all, for reading. It is a fact that about 85 percent of what appears in most newspapers is text.

Uncomplicated page architecture

Good design uses a precise grid, with combinations of columns based on a specific set, let us say of five or six, from which other combinations are created.

Steps to design success

In 1981, in the first edition of my textbook, *Contemporary Newspaper Design,* I listed three challenges redefining the role of newspapers. Today these also apply to the various media:

- Accepting the emergence of television as a far-reaching medium for news and entertainment

- Satisfying the informational needs of a greater number of readers who have moved to the suburbs and created news microcosms within the large metropolitan area

- Developing content relevant to the changing lifestyles of young readers and reestablishing the newspaper habit among the large number of nonreaders

For the most part, these challenges remain with us. But if I were to reconsider them for today's publication-design environment, as a publisher recently asked me to do, I'd list the top three contemporary challenges redefining the role of newspapers as these:

- Include local news. It's what readers everywhere crave, followed by better and easier-to-use information on health, technology, and personal finance.

- Coordinate with your website to provide more service-oriented features and lists. Lists do very well with today's readers.

- Introduce supplements for younger readers, not necessarily about entertainment but about issues of specific interest to this age group.

These challenges make the process of change, of redesign, even more important than ever before. The key is gathering all the pertinent information before the project starts, and then establishing a time line that accommodates a gradual process.

Here are some steps that are crucial to redesigning any product, from a simple two-page brochure to a major annual report, magazine, newspaper, or website:

- *The briefing stage:* All those involved discuss the scope of the project: where they wish to take the subject of the redesign, visions of the future (a redesign is done for the next two to four years, not for the here and now), changes in content (which are *vital* to a good redesign), navigation of the new product, and links to its website.

After this briefing, the team is ready to work on sketches, to visualize abstract discussions, to make them a bit more real.

■ *The sketching phase:* Here the designers prepare two or three versions with different styles and typography to present for discussion. This is one of the more creative aspects of the project, and my favorite. The sketches are presented, and discussed by all, and then some conclusions are drawn. Now we either go back to the drawing board and start again, or we take concepts from here and there, to incorporate into a more final prototype.

■ *The prototype phase:* Here the team puts together a complete sample of the new product incorporating all the agreed-upon changes. Perhaps this version is tested with focus groups, which are then discussed and analyzed, and a final prototype is then prepared.

■ *The implementation phase:* The team prepares a style manual and trains designers and subeditors for the launching of the new design. Training is an important part of what happens here, since it guarantees that a design will be followed.

Design for people and place

Finally, publications, especially newspapers, must fit in with their city, their readers, and the communities they serve. Each newspaper must have its own identity and personality and not copy that of another paper. Aesthetics are secondary to individuality.

Newspapers that do this will be around for many more years. Pure design does not work outside the limitations and requirements of the technology we use to produce our work, and, most important, without taking into account the realities of marketing, circulation, and the changing reading habits of people who live in an unprecedented information revolution.

The most successful projects are those in which a content realignment precedes the redesign process, and the editors are ready to tackle the issue of how to highlight that good content through design.

To that effect, we start with the creation of story structures, which eventually lead to typographic components and then to the right page architecture and color palette.

I could probably have told that doctoral student who asked about theories of newspaper design that the phases described above, although not specifically theoretical, constitute the basis of good progression for design generally, allowing both journalists and designers to divide the work into units that link processes and stimulate creative thinking.

And pure design does not exist without a good sprinkling of common sense, the ability to surprise oneself with new concepts, and that element of passion that separates the magnificent project from the rest. ■

pure design

words

Engines to good design

Designers who respect words gain the respect of the editors with whom they work.

Respect for words shows on every page. Words hold the key to our senses, in ways that perhaps visuals, even the power of color, can't. We may be influenced by the presence of a bright hue on a page, but words mesmerize and are remembered long after our eyes have gone on to seek other sensations on another page. Not long ago, Tom Brokaw was presenting a lead-in to a documentary on the baby boom generation. He was seated at his desk in a dark suit, with nothing around him but the weight of his words. The words themselves were far more powerful than any of the footage shown.

For the designer, words have practical applications:

- Certain "key words" give us visual clues. Cling to adjectives ("this was an over-the-top school principal"), to descriptive phrases ("it had not rained for days; all was dry and brown") or point of view ("there was nothing humorous about this meeting"), and seek ways to reflect them on the page. The tone of the words leads to the tone of the design.

- While reading a manuscript, a good designer underlines any passages that describe potential visuals.

■ Even when words are used to point directly to an aspect of a story such as " what the strike means," the designer can then utilize visual tools to make the material more comprehensible.

■ It is an interesting exercise, and one I recommend, to start by writing a short paragraph describing what a design project is all about. I find myself making notes that read:

"This is a text-driven newspaper where what one reads is more important than what one sees."

"Here we must explode with energy on every page: the bold, the large, the bright hues, all are protagonists in this circus-like environment."

"A website for those who wish to meditate and contemplate: go easy on the bright images; find dropped capitals to intercept here and there."

When a reader sees a page, it is the words he or she begins with. No matter what you are designing, begin with words. So we begin our study of pure design with words. ■

Layering stories

Headlines are beacons leading us to a destination. Because the destination is usually a mass of text, smaller beacons, such as deck heads or summaries, also contribute to getting us into a story. But for these devices to work well, copy editors must make sure that each new element within a story structure adds information, that they do not simply repeat the thought from the headline in the deck and in the summary.

When I worked with the *Philadelphia Inquirer,* the editor would not release the completed redesign until everyone on the copy desk understood and applied the concept of integrated editing: ensuring that each element in the story structure contributed an added dimension of the story.

At the Asian and European *Wall Street Journals,* the lead structure on each page uses three elements preceding the text. The main headline, our primary beacon, whets our appetite. The second deck amplifies what the story has to offer, and additional decks or summaries take us by the hand—or the neck—into the text. ■

Hand in hand: The *Philadelphia Inquirer* editors and designers know that writing, editing, and design combine to give us pages where words and images meet in a harmonious marriage. Headlines and photographs/illustrations convey different aspects of a story. Collaboration between editors and designers leads to the best-designed pages.

Summaries

Headlines and photographs are our most effective tools in grabbing the attention of readers. However, designers and editors know that summaries—four- or five-line paragraphs that appear between the headline and the first line of text—can also be good hooks.

Popular in magazines, summaries have made a great entrance into newspapers and other printed matter. The well-written ones do not repeat what the headline says; instead, they flesh out the story to give scanners an idea of what the story is about.

Typographically, summaries should be set in a minimum of 12 points and should offer contrast to the headline. A very light headline might use a bold summary, and vice versa.

Avoid using very long summaries. One-column summaries should not exceed eight to ten lines. If spread over two columns, summaries should be a maximum of six lines. Summaries should not appear as an impassable block of text. Instead, they should be extensions of the headline, another point of entry to interest the reader. ∎

Taking the headline further: For "scanners," summaries may be all the story they take with them. Santiago's *El Mercurio* uses summaries intelligently, never exceeding eight to ten lines of text.

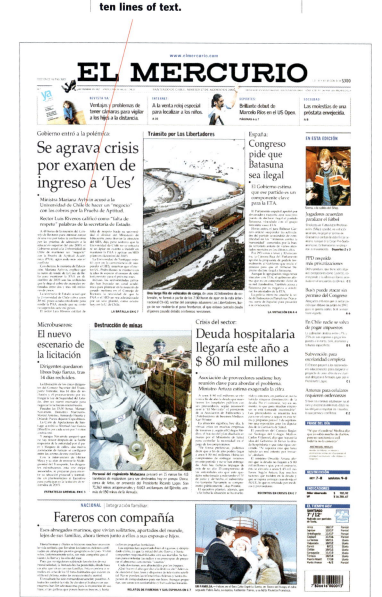

A brief should be brief

When we conducted the often-quoted Poynter Institute Eye-Tracking Research, it became obvious that briefs—those short and nicely packaged columns that run up and down the page—enjoy some of the highest readership. More than 69 percent of all the briefs that appeared were read in their entirety.

We should incorporate briefs whenever possible, giving them a prominent place on the page. Most newspapers run brief columns vertically, usually on the outside of the page, with small, bold headlines and type set ragged right, to distinguish them from regular text. But at the *Wall Street Journal Europe,* the new design calls for brief columns to appear anywhere but on the edge, making them a more integral part of the page.

News websites have enhanced the status of briefs. A new generation of readers is used to scanning and scrolling up and down to get summaries of stories they may eventually read in their entirety. When those readers transfer to print, they expect the same, smooth type of visual "scrolling."

There remains a consistent problem with briefs, however. In many newspapers, they are not brief enough. A brief should be what the term implies: not more than fifteen to twenty lines in a one-column setting. If more space is needed, then the editor should create a compact story. Long briefs are unfair to the reader—and the story. ■

Reaffirmation news: Readers come to their newspaper to discover what they don't know or to reaffirm what they already heard elsewhere. Briefs rank among the most often read items in the newspaper. Editors know that these short items are best utilized with reaffirmation news. The *Wall Street Journal Europe* runs briefs on almost every page, complementing text-driven pages of news.

Whispers

The storytelling process we design on the page or screen should, as much as possible, imitate how we communicate the same stories orally. This is an effective way to introduce contrast and surprises. In normal conversation, there is seldom only *one* aspect of the story taking place; instead, stories run parallel to each other. We start talking to a friend about a movie we have seen but soon take detours (which are sometimes better than the original story.)

Likewise, in design, we must present visual detours. Traditionally called "sidebars," they are more than just that. If we use the conversation metaphor, these detours are "whispers." Say you are at a busy cocktail part and a speech is being presented. You "whisper" your sidebar to the person standing next to you. You add to the story. You bring in background information. You remind whomever you are talking to of an event in the past that ties in to the speech of the moment. When placed on the page, whispers are second readings, normally short (no more than five to six paragraphs) and carry their own headline, since many times they are read first.

Reporters and writers who understand the importance of storytelling should suggest whispers in their stories from the start; in cases when this does not happen, it is up to the designer to seek them out, to discuss possibilities with the writers and editors, and to present them.

As runners have known all along, sometimes the detour one takes from the usual route can provide the ultimate surprise. ∎

Secondary, but relevant: Use "side-bar" items to offer a glimpse into an interesting aspect of a story, to enhance biographical or other encyclopedic information, or to pull away from the narrative with a single element of the story that nobody should miss. This prototype page for the new design of *Liberation* (Paris) shows an interesting approach to a secondary read that stands out, aided by ample white space on the left.

Web design? Think books

Websites are not like newspapers, magazines, or television. In fact, they resemble the book more than any other medium. One buys a book because of interest in a specific topic. This is how users approach sites. A book requires total concentration, as does a website. More important, books normally separate text and photos; this is also something that should happen on websites.

In terms of writing, books keep us interested throughout the narrative. Websites should attempt to do the same. I believe that the use of the traditional pattern of journalistic writing—the inverted pyramid—may not be the best form to present information on news sites. Instead, knowing that the average computer screen allows about twenty-one lines of text before the user must scroll, we should abandon the inverted pyramid for more of a champagne glass structure, where every twenty-one lines or so the writer makes an effort to keep us interested. Anyone who likes champagne knows that every time the glass is empty, it is nice to have it refilled, and to watch new bubbles rise to the surface. ■

SkillsOne™
CPP, Inc. Publisher of the MBTI Instrument

Conflict Management & Productivity

▶ Resources
 ▪ Books
 ▪ Training Materials
 ▪ Links
 ▪ CPP Main Site

▶ Contact Us

Build Your Business

Step 1
Define your project: What do you want to do?
- Training with project groups to build teamwork skills
- Management training to increase communication skills
- SkillsOne™ training to help a business test larger work groups divisions and act as an interpreter of the data

Step 2
Get specific: Who do you want to train?
- Workgroup A has a second quarter deadline. It is more likely to meet that date by beginning teambuilding training using the SkillsOne™ tools.
- Manager group B is getting ready to complete its yearly strategic plan and would benefit from a structured discussion using the SkillsOne™ tools.
- Company C would like all of its customer support staff to take the TKI online. Use the SkillsOne™ dynamic group/individual profile to determine whether more training in accommodation is needed and to target the training to maximize efficiency.

Step 3
Check out SkillsOne™ training: We do a lot of the work for you.
- Check out the learning exercises area. You can even submit an exercise and be a featured trainer.
- Look at the trends and topics areas to get updates on human resource issues that are fresh.
- Visit the author's corner and get info and interact with the author.
- Visit cpp-db.com and expand the tools you bring to the table as a trainer or HR professional.

Easy to digest: For the publishers of the Meyers-Briggs personality test, Miller Media created an e-commerce site to highlight current products. Even at the deepest levels of the site, long running text was condensed, with stories edited into bite-sized chunks to pull readers through.

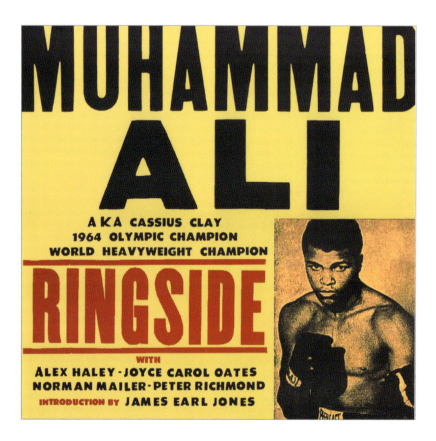

The influence of books: Book design clearly delineates image from text, also useful in Web design. But the story can also employ multiple points of entry. When Miller Media published a visual biography of the life of Muhammad Ali, the color images and running text told the story of his career. But another layer was added: readers could flip through the book and read the highlights of Ali's life through a series of large scannable captions and quotes.

1960s by Alex Haley

Clay vs. Liston:
Birth of a Legend

It wasn't until

When Cassius Clay was a baby, he was called "G.G." as he constantly babbled "G.G.G." After winning the first title, the 1959 Golden Gloves, he explained "You know what I meant? I was trying to say Golden Gloves."

> "Clay is not a fake, and even his blustering and playground poetry are valid; they demonstrate that a new and more complicated generation has moved onto the scene.... Clay is definitely my man."
> —LeRoi Jones

Ali-Holmes

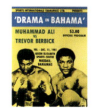

'DRAMA IN BAHAMA'

MUHAMMAD ALI vs **TREVOR BERBICK**

$3.00 OFFICIAL PROGRAM

FRI. - DEC. 11, 1981
QUEEN ELIZABETH SPORTS CENTRE
NASSAU, BAHAMAS

After his loss to Holmes, Ali was matched with Trevor Berbick in 1981. Before the fight he crowed: "Forty is fun, because life has just begun. Age is mind over matter—as long as you don't mind, it don't matter." Ali was beaten in ten rounds; it would be his last fight. Afterward, he admitted: "I was slow. I was weak. Nothing but father Time, I know it's the end."

> I'll be the biggest fool in the world to go out a loser after being the first three-time champ. None of the black athletes before me ever got out when they were on top. My people need one black man to come out on top. I've got to be the first.
> —Muhammad Ali

Web influences

The survival of print magazines and newspapers depends heavily on editors' ability to embrace new media. The future consists of people living in a multimedia environment. They will read on the screen as well as on the printed page. Smart editors will make sure they keep users moving from one to the other, emphasizing the pluses of each as they refer between both.

One of the advantages of the printed page is that it provides a sense of closure. A newspaper or magazine has a beginning and an end, a first page and a last, whereas websites are an endless barrage of information. An editor can take advantage of this; he or she might publish a few paragraphs of an interview in the paper—just the right amount to tell the story—and refer those interested to a site where the remaining text appears.

The best publications already include guides to the Internet. Just as we all find that bibliographies at the end of chapters enhance the utility of books, modern readers welcome a good list of selected web sites to consult on a covered topic.

But the real influence of the Internet on print may be in indexes, navigational devices, and better use of functional color. The Web has made us more aware of indexes, facilitating what we wish to find and leading us there. Print media (not notorious for making navigation easy) can now regularly be seen applying these lessons

to contents pages, covers, and other indexing tools. As for color, we are beginning to use it like never before. Web designers have discovered color as a functional element for moving the user from one side of the screen to the other. Print designers are imitating the technique, with great success.

There will always be printed newspapers and magazines in some form (smaller formats, for sure), but the strong publications will be allies of everything we are learning from the Internet. ∎

HEADING UP IN A DOWN YEAR

Hispanic Business 500 revenues grew 10.9 percent in 2001, despite a national economic slowdown.

By any measure, 2001 stands out as an unusual year for business. During this historic shift from peace dividend to war economy, from expansion to recession, the **Hispanic Business®** 500 continued its impressive course of double-digit growth. Revenues for the 500 largest Hispanic-owned companies in the nation increased 10.9 percent to $23.49 billion (see chart). In contrast, the national GDP grew 3.4 percent in 2001, down from 6.5 percent the previous year, and revenues for the *Fortune* 500 grew only 3 percent.

So how did the **Hispanic Business** 500 hold their own, and even prosper, during the downturn?

Part of the answer lies in the composition of the 500 itself. Economic contraction occurred mainly in business investment and the capital goods sector, while consumer-oriented sectors suffered less. Among the 500, wholesalers and retailers report the highest revenue percentage growth, at 33.6 and 17.4 percent, respectively. Construction,

automotive, and transportation also show substantial growth. The business-heavy finance sector contracted by 25.3 percent (see table, "Sector Composition & Performance"). The service sector, which includes both business and personal services, averaged a 4.4 percent growth rate. Clearly, the consumer segments on the list helped counterbalance losses among B2B sectors.

According to the Bank One Economic Outlook Center at Arizona State University, automotive purchases ranked among the strongest categories of consumer spending during the slump. Seven of the top 20 companies on the **Hispanic Business** 500 sell cars, and these giant dealerships increased their sales by $544.62 million in 2001. Burt Automotive – the number 1 company on the directory, with revenues of $1.49 billion – accounts for more »

TOTAL REVENUES* OF THE HISPANIC BUSINESS 500

Year	Revenue	Change
2001	$23.49	+10.9%
2000	$21.18	+12.8%
1999	$18.78	+7.6%
1998	$17.44	+3.9%
1997	$17.09	+3.8%

Recession year *In billions

©2002 Hispanic Business Inc.

ON THE WEB

Visit www.hispanicbusiness.com/magazine/go/june02 to see more charts and data on the **Hispanic Business** 500.

METHODOLOGY OF THE HISPANIC BUSINESS 500 DIRECTORY

Hispanic Business research staff gathered data for the 18th annual listing of the 500 largest Hispanic-owned companies in the United States from the **Hispanic Business** Company Profile form, which appeared in the magazine's December 2001 issue. Also, Company Profile forms were mailed to more than 14,000 Hispanic-owned companies in the United States.

Companies included in the **Hispanic Business** 500® must show at least 51 percent ownership by Hispanic U.S. citizens and must have headquarters in one of the 50 states or Washington, D.C. Companies must submit revenue figures based on their report to the IRS on line 1c of the corporate/partnership tax return. The revenue figure must be submitted on a signed form verified by the CEO, CFO, or a CPA representing the company. Nonprofit organizations, advertising and public relations agencies, and companies based in Puerto Rico are not eligible.

While **Hispanic Business** makes every attempt to locate and include the largest Hispanic-owned companies in the country, we cannot list companies that do not submit the required information by our deadline.

To ensure that your company is considered for future **Hispanic Business** directories, please send your name, company name, mailing address, phone number, fax number, and e-mail address to our Research Department via fax at (805) 964-6139 or via e-mail at research@hbinc.com. Indicate that you would like to have a Company Profile form sent to you.

Cross-Platform: *Hispanic Business* magazine includes Web references in all of their stories. These include links to reader-feedback pages, online polls, and extended versions of stories.

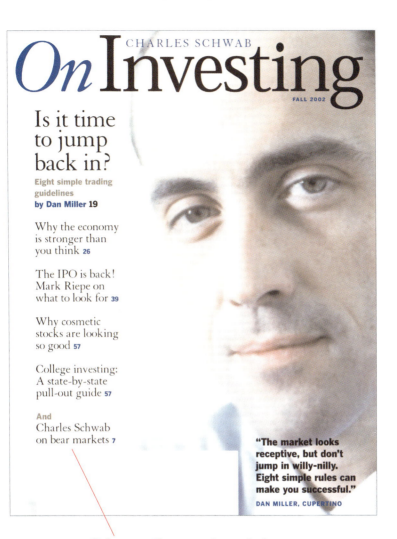

CHARLES SCHWAB
On Investing
FALL 2002

Is it time to jump back in?
Eight simple trading guidelines
by Dan Miller **19**

Why the economy is stronger than you think **26**

The IPO is back! Mark Riepe on what to look for **39**

Why cosmetic stocks are looking so good **57**

College investing: A state-by-state pull-out guide **57**

And
Charles Schwab on bear markets **7**

"The market looks receptive, but don't jump in willy-nilly. Eight simple rules can make you successful."
DAN MILLER, CUPERTINO

Indexes on the cover: Increasingly we notice that magazine readers don't spend the time to read the table of contents. John Miller and Aaron Kenedi have been in numerous focus groups in which readers preferred cover lines with page numbers to find what they wanted. So when they designed Schwab's *On Investing* magazine, they created a cover strategy that featured a mini table of contents—perfect for scanners.

Photograph captions

After headlines and photographs, photo captions capture the most attention on a newspaper or magazine page. Editors with insight realize that these small text blocks represent a powerful tool in the storytelling process. In fact, research shows that readers seldom move into story texts, that just scanning the other page elements (including captions) satisfies their appetite. Knowing this, what can one do to make photo captions more effective?

- Always make caption type at least one point size bigger than that of the story text.

- Increase the leading, or interline spacing, of caption text. Doing so enhances legibility.

- Start each caption with a bold element. A good device is to start with one or two words in bold, written like a miniheadline.

- Avoid using the caption to describe what is obvious from the photo or what is already stated in any accompanying story's headlines. Instead, provide additional information and enhance storytelling.

- Stand-alone photos, without accompanying stories but with fully informative captions, are particularly effective. Readers love them; good editors use them whenever possible. ■

pure design

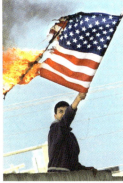

Powerful story enhancers: Photo captions prove to be the storyteller's best ally in guaranteeing that information is ready by lots of readers.

Longer isn't boring

Perhaps it is a result of September 11, or partially the influence of the Internet, but there is no doubt that texts run longer in newspapers everywhere these days. This is a good thing. And for copy editors and designers who worry that longer texts mean more inaccessible or unattractive pages, my answer is that it does not have to be so.

Even that pioneer and master of the short text, *USA Today,* seems to have opened the door to a few extra lines of text, especially in its cover stories.

The good news is that many of these long texts are being read. This spark in reading is not limited to newspapers, by the way. the *Wall Street Journal,* in a November 9, 2001, cover story, reports that the under-twenty-five crowd is purchasing books in record numbers: "After a decade in which reading was considered about as hip as the Bee Gees, the under-25 set is now buying books for leisure reading at three times the rate of the overall market." The *Journal* continues to explain that bookstores across the United States report jumps in sales of 20 percent to 75 percent in young buyers over the past three years.

If this younger generation of readers enjoys their newly discovered activity, it is likely that they will start reading newspapers again. This is a good time for marketing and circulation folks to tune in to this trend and to revitalize their sales and promotion campaigns to tap into this difficult-to-target group.

What do we need to do to present these longer stories effectively?

- Make sure you have a very good headline that fleshes out the entire story. And, remember, longer texts require larger heads. They are the first signal to the reader of the story's importance.

- Establish the type of story structuring that goes beyond the headline, to include one or two decks (or additional smaller headings.)

- Incorporate subheads at strategic points throughout the text. Place subheads at transitional points in the story, since many scanners may wish to move to the next interesting segment. (Simply because the text is long does not mean that readers will read it in its entirety. Facilitate navigation *within* the article itself. This is an important step, journalistically as well as visually.)

- If visuals are available, play editor, and select the one image that is definitive in presenting the story. Avoid the temptation to incorporate too many visuals, some of which may not contribute much to the storytelling process.

If long texts are in, and more readers are coming to the pages we create, we must rally to the occasion. Facilitate movement in a dignified and simple way. Let the value of the story be the engine that gets and keeps the reader interested. ∎

Redesign while you still look good

A nervous publisher once asked me, "When is it time to redesign your newspaper?"

The answer to this question is not always easy but is quite consistent. Many of the editors and publishers who call me do so when their publication has had a dramatic drop in circulation or when a competitor moves in. Sometimes when new editors arrive, they want to innovate, to put their own visual stamp on the newspaper.

While all of these reasons may be valid, a redesign really should be a continuous process in the life of a publication and should not be prompted by dramatic events.

More than before, change is essential for a newspapers and magazines to survive. The competition is fierce. Readers are bombarded by more information than they can possibly process. Papers can't afford to wait until they look so out of date that they're losing readers.

The best redesigns happen when publications still look good. They're looking ahead to the next five years. ■

When beautiful turns better: *Liberation*, every designer's choice of one of the world's most visually appealing dailies, was turning thirty and wanted to change its look. What to do when one starts with an aesthetic winner? The Garcia-Media team first reviewed the history of the legendary Parisian newspaper, then conducted workshops to review ways of integrating that rich past into a more interesting presentation of the news and features.

Case Study | Die Zeit

The Challenge: No amount of preparation could ever be enough to tackle this weekly German icon of intellectual journalism, a newspaper that included on its board of directors Marion Gräfin Dönhoff, one of the most distinguished woman journalists of the twentieth century, as well as former German chancellor Helmut Schmidt, plus dozens of extremely bright and opinionated editors. We did eleven different sets of sketches during the twenty-one months that the project lasted. The first draft was not considered elegant enough: photographs were too big, and some sections were too much like "those British Sunday magazines." The next draft was too colorful. Then there was the version that emphasized illustrations, and the version that introduced a colorful promo bar. I still can hear the resounding:"Take it away, this is not us, not now, not ever."

What we did: After multiple failed design proposals, we decided that a workshop setting, with key editors sitting down with us to "sketch" the paper, would be ideal. My designer, Foster Barnes, and I set up shop in a room with two Macintosh computers, a printer, and a screen. Sketches with headlines and text came to life on the screen, the editors commented, and, by the end of the first day, the new *Die Zeit* was emerging.

19. Dezember 2001 DIE ZEIT Nr. 52

17

WIRTSCHAFT

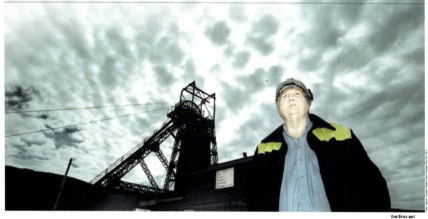

EIN BOSS MIT VISIONEN:
Tyrone O'Sullivan will unter Tage ein Erlebnishotel bauen. Doch seine Leute sind dagegen

Die Verführung eines Sozialisten

Er war der Held unter den walisischen Bergarbeitern. Dann verwandelte Tyrone O'Sullivan eine bankrotte Kohlezeche in ein profitables Unternehmen. Jetzt versteht der Chef die eigenen Kumpel nicht mehr / VON ANDREAS MOLITOR

„Morgen, Tyrone!", brüllt der Kauenwärter vom Gang aus durch die halb geöffnete Tür zum Chefbüro. „Lass uns für die Klos ab sofort Papierrollen statt Tissues bestellen?"

„Wieso das denn?", ruft Tyrone zurück.

„Rollen sind billiger!"

„Dann bestell von jetzt an eben Rollen!"

„Du misstraust du aber dem Lieferanten bezahltigen, Tyrone?"

Tyrone O'Sullivan verdreht die Augen. Da ist er nun: Chef einer Firma mit 300 Mann und 20 Millionen Pfund Jahresumsatz und muss entscheiden, womit seine Leute sich den Hintern abputzen. „Diese Klos sind das Letzte", knurrt er, während er in seinem Urals-Organizer die Telefonnummer des Lieferanten sucht. „Jeiu Mensch fühlt sich dafür verantwortlich, dass es sauber gemacht wird." Jetzt hat er die Nummer gefunden, wählt. „Tyrone hier. Die Tower-Klos, wie, mehr ab sofort Klopapierrollen statt Tissues, okay? ...

Tyrone sieht sehr glücklich und ein bisschen betrunken aus auf dem Zeitungsfoto, das in der Besucherkneipe der Zeche an der Wand zappt. In der linken Hand eine Flasche mit siebenhundert Anti-Schaumwein, der sich auf seinem weißen Hemd schon großflächig ausgebreitet hat, im Hintergrund der Förderturm von Tower. Es ist ein Foto vom Tag des Sieges. „Wie waren ein Haufen dummer Bergleute mit einem Traum", heißt die Schlagzeile. „Jetzt ist er wahr geworden?"

Der Nervenkrieg in Hirwaun

um das letzte Bergwerk in Südwales spitzt sich im Frühjahr 1994 zu: Die Kohlebehörde erhöht das Abfindungsangebot auf 60 000 Mark pro Mann. Doch die Kumpel lehnen ab – und übernehmen den Betrieb in Eigenregie. O'Sullivan: „Wir waren ein Haufen dummer Bergleute mit einem Traum" – und der wurde wahr

Und Tyrone O'Sullivan, einst militanter Kampfgewerkschafter, ultralinker Klassenkämpfer, der dicke Tyrone ist der proletarischen Fahne, er ist nun der Chef. Erster unter Gleichen.

„Ich bin der Vorsitzende dieser Firma hier", verkündet Tyrone den Schülern, die an diesem Vormittag zur Cardiff zur Zechenbesichtigung gekommen sind, „und das bedeutet, dass ich der Boss bin. Ich bin der Boss von allem, was du hier siehst."

Fortsetzung auf Seite 18

Nr. 33 8. August 2002 57. Jahrgang www.zeit.de C 7451 C Preis Deutschland 2,80 €

DIE ZEIT

WOCHENZEITUNG FÜR POLITIK · WIRTSCHAFT · WISSEN UND KULTUR

Wahlkampf, letzter Akt

Wer wird regieren?
Jan Ross porträtiert
Joschka Fischer und
Wolfgang Schäuble S. 2

Schröders letzter
Trumpf: Die Vorschläge
der Hartz-Kommission
Von E. Niejahr S. 3

Wie die SPD versucht,
dem Wahlkampf noch
eine Richtung zu geben
Von G. Hofmann S. 5

Wahlprogramme sind
besser als ihr Ruf.
Wilfried Herz hat
sie gelesen S. 19

Kein Pardon für Polen
Die EU erkennt die Lasten und
Vorleistungen des Beitrittskandi-
daten nicht an / Von Christian
Schmidt-Häuer Politik S. 7

Frei bis in den Tod
In Holland ist die aktive Sterbe-
hilfe straffrei. Der Streit um den
letzten Willen geht weiter / Von
Christian Schüle Wissen S. 23

Austers Wundertüte
Der neue Roman „Das Buch der
Illusionen" zeigt Paul Auster auf
der Höhe seines Könnens / Von
Ulrich Greiner Literatur S. 35

Letzte Szene einer Ehe
Kein Blut, keine Leiche: Der
Lübecker Crantz-Mordprozess
geht in seine nächste Runde
Von Sabine Rückert Leben S. 43

Das Scheingefecht

Nur keinen Streit: Deutschland unter der Konsensglocke / Von Michael Naumann

Krieg gegen Saddam? Nicht ohne bessere Gründe

Europas Fragen an Bush / Von Matthias Naß

Gleich Krankenschwestern aus Betten einer Intensivstation haben die Demokratie vor Monaten die wechselnden politischen Befindlichkeiten des Bürgers genannt. „Profilneuropathie" zwischen Gerhard Schröder und Edmund Stoiber aufheitern sich nun Besetzungszenter einer sentimentalen TV-Serie: „Wer ist glaubwürdiger, sympathischer, ein Sieger-typ?"...

Der Wähler ist immer undankbar

...

Der entfesselte Souffleur

...

Der Duckreflex des Kandidaten

...

Ritzen, Sex und Meerschweinchen:
Pubertät im Jahr 2002 – den
Kindern fehlen Vorbilder,
Perspektiven und Grenzen.
Nie war es schwerer, erwachsen
zu werden, als heute / Von
Roland Kirbach Dossier S. 9

Das Abenteuer", vor dem Gerhard Schröder warnt, wird inzwischen vorbereitet. Amerikanische Bomber steigen von Stützpunkten in acht Ländern auf, seitee die irakische Luftabwehr außer Gefecht...

Mehr Terror, mehr Tote

...

Gegen den Rat der Freunde

...

ZEIT Online GmbH: www.zeit.de
ZEIT Stellenmarkt: Verlag Buerius GmbH & Co. KG,
20079 Hamburg Telefon 040 / 32 80 - 0.
E-Mail-Bestellung: zeit-abo-service@guj.de
Service: Tel. 040 / 32 80 57,
E-Mail: abo-service@guj.de

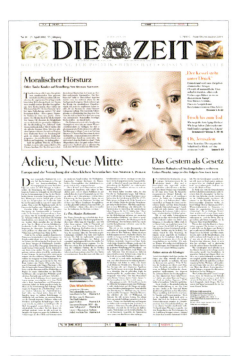

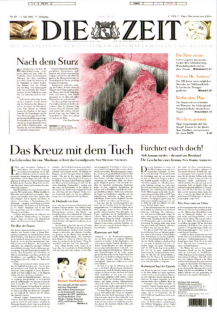

What we did: For the front page of *Die Zeit*, we proposed five categories for art:

- The abstract photograph: a subtle connection to the topic, not a direct news link.
- The caricature as photo illustration: a caricature with technology applied, so that the end result looks like a photo in texture, but with the humanity of the drawing.
- The cartoon as photo illustration: an editorial cartoon, with photographic techniques applied.
- The artistic photograph: a photograph that is simply artistic merits space.
- The pencil drawing as photo illustration: a traditional drawing, digitized, with the end product a combination of old and new.

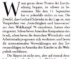

Vom Elend der kleinen Schritte

Wieviel Reformen verträgt das Land? Der „Modernisierer" Gerhard Schröder steckt in der Wahlfalle / VON WERNER A. PERGER

BEHAGLICH ZURÜCKLEHNEN – DAS GEHT NICHT MEHR IN DEUTSCHLAND. Die Globalisierung verbietet Nichtstun

What we did: We retouched the original redesign in 2000 when new editors wanted more text and larger photographs. Both were very good decisions, as the newspaper managed to become newsier and attract younger readers.

DIE ZEIT Nr. 10 18. Juli 2002

Leben

Der Juli
Daniel Bahr ist mit sich und der
Gesellschaft im Einklang. Ein Gespräch
mit dem Chef der Jungen Liberalen 46

Foto: Unbekannt/laif für DIE ZEIT Leben

»Bezahlen kann ich, wenn ich tot bin«

*Sie leben gut, aber sie können ihr gutes Leben nur auf Pump
finanzieren. Wichtiger als ihr Kontostand sind ihnen Stil und Haltung.
Ein Bericht über die neuen Bohemiens.* VON WOLFGANG FARKAS

ARM ODER REICH? Egal Hauptsache, die äußere Wirkung stimmt

DICHTER DRAN

Bestückt euch!

ANTJE RÁVIC STRUBEL,
28, verkleidet sich als Mann
und kann trotzdem die
Gesellschaft nicht retten

Fortsetzung auf Seite 44

Lebensinhalt

What we did: The creation of a
totally new supplement called
Leben, which our team carried
out under the direction of
Theresa Kral, allowed editors to
present a product targeted to a
young demographic.

type

HOW TO USE FONTS

Selecting type

Perhaps no task is more painful for the designer than the selection of typographic fonts. Many agonize over their choices. Today, with so many well-drawn alphabets, the task becomes even more difficult. Here are some tips for picking type:

- Fonts should be easy to read. Especially for text type, it is best to use type of 9 points or above; many newspapers even go for 10 points for texts, knowing that their older readers appreciate it.

- Fonts should allow for contrast. Headlines should be bold, and in large sizes, and typefaces should provide contrast through combinations of demi and lighter tones.

- The font should include a well-designed condensed version. Headline writers will always appreciate this.

- Fonts should include an elegant italic. It is always needed.

- Fonts should be appropriate to the publication. I have said many times that there are Bodoni towns and Helvetica towns. Relate your selection to the culture of the publication's home.

- Finally, do not select trendy fonts that will not age well.

Fortunately for designers, classic fonts will always be around. My desert island favorites are: Caslon, Baskerville, Scotch Roman, Franklin Gothic, Frutiger, Bauer Bodoni, Griffith, Miller, Poynter and Old Modern. ▪

CARDBOARD

Boxes in strange dimensions

63 Cubits

ROLL OF CLEAR PACKING TAPE

POINTED KNIVES

Little Styrofoam Peanuts Were So Adorable

New Acquaintances

They became my most trusted confidantes

Late Practices

I taught them some dance routines

Let me tell you, getting them to listen carefully was difficult

SYNCHRONIZE

Packing Material on Ice Opens on Broadway

Ecstatic Reviews

Versatility: Pick a font that has numerous weights and italics. Miller Display has fourteen variations. It is also available in text cuts.

It's all in the details

A redesign is complete. Reader reactions start pouring in. Editors and designers meet to see what works and what doesn't. At the end of the day, when the process is finished, it is all in the details: not only for the editors and designers involved in the redesign, but, of greater importance, also for the readers.

While many of us start with the larger "strokes" of the design— selecting legible and attractive typefaces, creating good page architecture and an appropriate color palette, the truth is that many secondary details make or break the overall look and feel of a design. What are some of those details?

- *Folio lines:* These minute elements tell us the page number, the date, and the name of the publication. Make them easy to read, and, if you can, create a little personality for them. Not every folio has to be one horizontal line on top of which type sits. How can the folios reflect some aspect of the rest of the design?

- *Bylines:* There will be hundreds of bylines in the average publication. They should not call too much attention to themselves but also should not disappear. Give bylines a job: to provide typographic contrast between the headline that precedes them and the text that follows them. And don't forget to create special byline styles for longer reports, exclusives, and for noted writers and columnists.

- *Captions:* The Poynter Institute's Eye-Track research demonstrated how popular captions are with readers. Make them come alive. Provide captions with good information that does not repeat what is visible in the photograph; and make the type sing, providing contrast with the text of stories around them.

- *Photo credits:* Small as these are, they are important. Ideally, place them bottom right under they photo, with type that provides contrast to the caption that follows it, in all caps, for example.

- *Refers:* The lines that tell you that there is a related story somewhere else in today's edition, or that an Internet version is also available, should be wonderful opportunities to apply good typography and effective visual thinking. ■

Think text first

When we paint the canvas of a page, or screen, most of our strokes are going to be text. We fill entire columns with text, we incorporate headlines, bylines, and captions under photographs; we highlight quotations or facts, include boxes with statistics, and we dress up the pages with headers made up of words. About 80 percent of what appears on a page is going to be text, *not* photos or illustrations.

It is no wonder, then, that good designers begin strategizing by thinking about typographic elements for the page. Combining good text fonts, with an interesting architecture, and adding touches of contrast (bold, italics, light, condensed) as well as color, completes the package. Here are some tips on using text:

■ Start your design by selecting a text font, since that will lead to the rest of your choices.

■ Find a text font that allows for high levels of contrast, so that hierarchy as well as highlighting of certain words is possible.

■ Look at the text font in various sizes, so that a story could begin, in, say, 12 or 13 point, and then decrease to 10 point.

■ Don't make text smaller than 9 points; go with 10 when possible.

■ Pay attention to leading—the space between lines.

Remember that when you dip your design brush in the can, it is mostly text that you will be painting with! ■

In-depth and readable: The *Wall Street Journal* is a text-driven product so it was designed with text as the first and foremost consideration. Occasional graphics and illustrations are employed to help the story along. Notice the use of white space to make the page easier to follow.

49

When design looks outdated

Typically, five years or more after even the best redesign, wrinkles start to show in a publication's appearance.

The first wrinkles appear in typography, often in the headers used to identify sections and individual pages, or in small-type areas such as listings and the type used for infographics.

The second wrinkles appear in story-structuring details. Redesigns of a few years ago paid less attention to the process of creating hierarchy on the page. Many publications relied simply on headlines to get readers into the text; we now know that it takes other devices such as summaries and secondary headlines to achieve that.

The third wrinkles usually show up in the use of color. A palette acceptable a few years ago may no longer look as good, or the publication may be after a different target readership or it may have different printing equipment with different color capabilities.

When wrinkles appear, first study what they are, how they affect the overall design of the newspaper. Often, one does not have to redesign the entire publication to make some quick but long-lasting fixes that can have a wonderfully rejuvenating effect. ■

Ragged right vs. justified

It happens often that an editor and a designer argue over how to set the type for a specific story. The designer may wish to have the text set ragged right—meaning that the right hand margin will not be justified as a block. The editor argues that this trivializes the content of the story.

When it comes to ragged right versus justified type, the research does not point to very specific differences in terms of the legibility of one or the other. However, it is true that readers tend to associate ragged right with columns and features, but that is because it has been traditionally used this way.

Ragged right can be helpful in providing a bit of white space on a crowded page. I recommend it for shorter, not longer, texts. A small box or second reading in the middle of a mass of dense text, set ragged right, provides breathing room and lightens things up within the architecture of the page.

Remember, a vertical column of ragged right type should always be accompanied by a thin vertical column rule, to prevent the ragged lines from running into the material to the right.■

Headlines: bigger is better

For some reason, headlines have become smaller in many newspapers. Yet readers like headlines that are bigger, especially on inside pages. Every newspaper should have a set of guidelines for the range of sizes of the lead headline. This in turn determines the proportional size of all other headlines on the page.

For instance, say a broadsheet newspaper carries, ordinarily, a 48-point headline for its most important story (and that may be small, since 54 points or bigger creates more impact). Then the next important story on the page should have a 42-point headline, and so on.

What we see these days is a lead headline in 36 points atop a page, with the rest of the headlines "whispering" their content.

Readers are helped when a page instantly conveys the hierarchy of stories based on headline size. To do less is not to serve your readers well. ■

Read all about it: *El Tiempo* in Bogota depends on street sales. But that's just one reason its editors use large headlines. Just as important, the headline volume matches the volume of the content.

Storytelling

The single headline is becoming a thing of the past. Multideck headlines result in a more reader-friendly newspapers.

With more readers scanning as they move through their daily newspapers, the role of headlines has tripled in importance. Their prominence, usually being at least three times the size of the story text, gives them great power to lead readers into stories or to help them decide to bypass a certain story in search of another. To aid this scanning process, add "decks" or "extra thoughts" to headlines. There is an art to doing this properly, however;

- The first line gets into the story; subsequent decks add more information so that overall they convey the essence of the story.

- Multideck headlines must offer typographic contrast. If the main headline is bold, then the decks should be lighter in weight. A roman main headline may be accompanied by decks in italics. Some newspapers colorize decks.

- Multideck headlines must offer size contrast. If the main headline is set in 36 points, the first deck might be in 18 points, and the second in 14.

- Multideck headlines can highlight an exclusive story or an important author. The British newspapers do this well, using decks to go beyond storytelling into unusual aspects of the story. ∎

The Garden of Eden

arch 1957. Ernest Hemingway visis Tortuga where he would begin what was to be his final novel. Now we excerpt it here, for the first time ever.

THE WARM WIND find a stock that has enough growth put out also that you can k for the first add on to k for a number of years? Not as easy as it may At least not those days.

Many investors look at night toward the investment strategies favored by a large number of Wall Stid as that you can k for the first add on to k for a number of years? Not as easy as it may At least not those days.

Many investors look at night toward the investment strategies favored by a large number of Wall Street and and of the etc. Sadly these Barbie the ya Not as easy as it may around At least not those days much that has enough growth put out also that you can hold on to k for a number of years? Not as easy as k may around. At least not those days.

Many investors look at night toward the investment strategies favored by a large number of Wall Street analysts. Sadly these Stock Rod has the pubg

Ernest Hemingway was born July 21, 1899, in Oak Park, Illinois. The second child and oldest son of Clarence, a doctor, and his wife, grew up in the in Chicago suburb of Oak Park and spent summers with his family at their cottage on Walloon Lake in upper forty Michigan (an area he later used.

Adding stories: When John Miller worked on the first *Esquire* fiction issue, he added a layer of story-telling to the fiction pieces: an extended caption on each opening spread, which gave readers the story behind the stories.

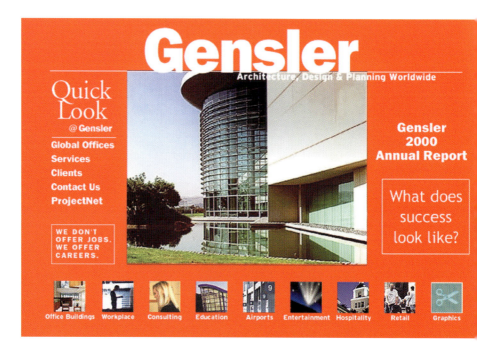

Stories on the Web: Gensler, the international architecture firm, had a problem. Clients who came to them for, say, airport design, were not aware of their other offerings, like retail design—which might be very useful to someone building an airport. An explanation of this in some sort of philosophy or capabilities page would be ignored by users. So Miller Media created a corporate site built around rich minisites for each practice area. When you come to the homepage of the airport's minisite, it's filled with news of current projects and links to relevant content in the other minisites, like Gensler's work with retail in airports.

Gensler Graphics

Quick
Look
@Graphics

Office Buildings
Workplace
Consulting

**Ingredients
.com**

Ingredients for
Success

Gensler Hospitality

Quick
Look
@Hospitality

Office Buildings
Workplace
Consulting

Kenmark

To Get Ahead
Get a Hat

**The
Fairmont's
Makeover**

S.F. Symbol
Gets a Makeover

Gensler Office Buildings

Quick
Look
@Buildings

▶ Office Buildings
Workplace
Consulting
Education
Airports
Entertainment
Hospitality
Retail
Graphics
Careers
Contact Us
Home

**Canary
Wharf**

London's
leading
business center.

**Hospitality
2000**

A New Era for
Hotels

**Place
Matters**

Bringing
everyone
together.

Fusion

We take an integrated approach to office building
design. We call it fusion: combining leading-edge
workplace strategies with proven building design
methods to deliver high-performance work settings.
The new Nikken Headquarters is a great example.
This approach has made us the world leader.

Italics: not just for features

At one point, perhaps in the 1950s, italics were mostly found in the "Women's" section of the newspaper. Fifty years later, thanks to newsroom legacy syndrome, the rumor persists: italics are not macho enough, you should never use them for sports stories, and never on hard news stories. And so one still sees italics restricted to articles about flower arrangement, new recipes for quiche, and the latest fashions from Paris. It is time to give italics a bit of credit.

Readers do not perceive italics as being less forceful—it is the words that make a headline strong or weak. And readers do not slow down when the headline is in italics. So italics can be useful as long as you follow a few guidelines:

■ Give italics a *job* to do through your creation of story structures. In other words, do not use italics for a feature today and for an opinion piece tomorrow, and then for a lead international story the next. Whatever their particular use happens to be, they should be used consistently and continually in that role.

■ Avoid excessive use of italics for text. Italics are more suitable for headlines, quotes, and highlights but are not as attractive in text size. ■

What a little slant can do: When we converted *The San Francisco Examiner* from a traditional broadsheet to a vibrant and colorful tabloid, one of the best decisions we made was to consider italics for headlines, not just for features, but for news as well. Especially on double-page spreads, like the one shown here, italics bring a certain elegance, a change of rhythm, and visual movement to the page.

Centered vs. flush-left headlines

Centered headlines dominated newspapers for decades, until, in the 1970s, more experimental newspapers began experimenting with flush-left headlines. Suddenly, newspapers would use the left-hand side of the page to align not only headlines but also other elements like bylines, summary paragraphs, quotes, and captions under photographs. One of the first newspapers to do this was the now defunct *Chicago Daily News.* The style was also adopted by the *Minneapolis Tribune* when, in 1971, it also switched to an all-Helvetica approach.

Since then, newspapers have opted mostly for flush-left headlines, especially in the United States, where centered heads are rare in any newspaper today. However, a quick trip across the Atlantic, and one finds the classic *Times of London,* continuing to use centered heads, as do many other European newspapers, as well as dailies in Asia and South America.

Any comment about one style of headline alignment versus the other would be based only on personal preference. However, how one aligns headlines does have an overall effect on the look of the page.

- Centered headlines give a page a more classic and traditional look; flush-left headlines are more modern and invite more white space onto the page.

- Flush-left headlines must be followed by a flush-left alignment for all other elements that follow it, while centered heads can very well be accompanied by bylines and other elements that are aligned to the left.

- Tabloids fare much better with flush-left headlines, while broadsheets can use either style.

- Consistency is important: keep either all heads centered, or all heads flushed left. However, some papers with centered headlines, such as the *Times of London,* do offer a bit of contrast by making the headlines for briefs flush left. This works better when there is also a switch of type font.

After all this, we are reminded that the wording of the headline, the message transmitted, the hook to get the reader to read the text is, at the end of the day, far more important than how one aligns the type. ∎

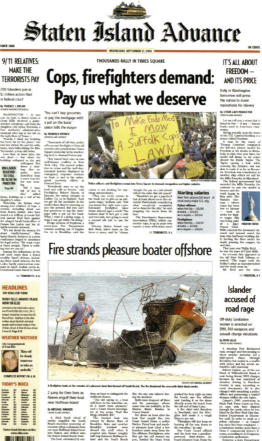

Elegant and easy to read: When Ron Reason first sketched pages for our redesign of the *Staten Island Advance*, he never imagined headlines in any other way than centered. Centering them was a way of lending elegance to a newspaper with a rich community tradition. Centered headlines also allow for good headline counts, which writers appreciate.

THE DAILY STAR

FRIDAY, SEPTEMBER 14, 2001 DISTRIBUTED WITH THE *Herald Tribune* THE WORLD'S DAILY NEWSPAPER FIRST PUBLISHED 1952 · NUMBER 10,386 www.dailystar.com.lb

US should aim for clear new policy

Lebanon shakes off its terrorist image

SUSPECTS NO LONGER MADE WELCOME

Butros: Syria wants to talk

TODAY

Revenue-hungry Cabinet endorses hike in gasoline prices

Motorists can expect to fork out an additional LL3,000 per 20 liters to fill up their tanks

Bush: Don't target Arab-Americans

High Breed TV

High Breed MONITOR

Outstanding DESIGN

The new Samsung SynchMaster 150/170 MP with Built-in TV tuner

Perfectly aligned heads: The *Daily Star* of Lebanon, designed by our Jan Kny employs flush-left headlines, which became popular in the 1970s. They help organize the page, with perfect alignment of elements that emphasizes a better use of modular layout. They also accommodate perfectly square modules much better than they do centered ones.

Type on photographs

If there was ever a subject that could get the emotions soaring in a newsroom, it is the dilemma of whether to put type (headlines) over a photograph or not. Photographers do not want anything to come between their photo and the reader; designers want "freedom" to express themselves; editors either love the practice or hate it. Some publishers I know ban the procedure entirely in their newspapers, sometimes for such trivial, but understandable, reasons such as: "My wife hates that." (True story!)

I have seen type over a photo make everyone look great: the photo, the story, the writer, and the designer, with readers smiling all the way, and I have seen it used poorly, especially when a type-happy designer mistakes the photograph as a drawing pad.

As with everything else in design, make it pure, make it simple. If the photo lends itself to it, put type on it, discreetly and as a secondary touch to the photo. And fewer words work best.

If a designer decides to put type on a photo, a conversation with the photographer will be appreciated. He or she may think the integrity of the image is being compromised.

But tread lightly when proposing it, and be ready to scratch your concept , since this is one of those battles that, in most cases, is not worth fighting. Save your energy for real issues, like writing a good headline that does not land on the great photo. ■

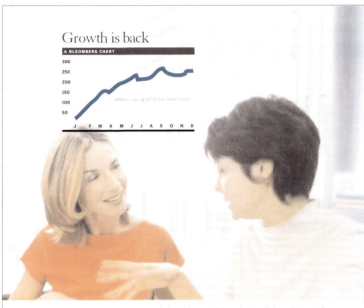

Growth is back

A BLOOMBERG CHART

Weekly closing of the top three funds.

J F M A M J J A S O N D

Are you balanced?
Sigmund Freud said,
no two patients are
the same. Schwab's
Amy Hiller And not
every one has the
same financial needs.
We're all very differ-
ent. What kind of
investor are you? And
not every one has the
same financial needs.
We're all very differ-
enfferent. And that's
how you scored.

vestors look straight toward the
investment strategies favored by
So where do you find a stock that
has enoughmay sound. At least not
these daysears? Not as.

Strategic Investor
Not easy any investors look
straight toward the investment
strategies favored by a large num-
ber of Wall Street analysts. Sadly,
these flashin the pabn strategies a
So where do you find a stock that
has enough growth potential so
that you can hold on to it for a
number of years? Not as easy as it
may sound. At least not these
days, re showing little resilance
in the recent bear market. In are

showing little resilance in the
recent bear market. In fact, statis-
tics show these are maong the
worst performers both in the short
— and long — term.
So where do you find a stock
that has enough growth potential
so that you for the first can hold
on to it for a number of years? Not
as easy as it may sound. At least
not these days.
So where do you find a stock
that has enough growth potential
so that you can hold on to it for a
number for tch first of years? Not
as easy as it may sound. At least
not these days.
Many investors look straight
toward the investment strategies

SCHWAB

Numbers and pictures: In an unusual
variation, John Miller designed
simple infographcs to be used over
photographs for Charles Schwab's
investor magazine. The effect achieved
an editorial goal: a strong link between
the relationships depicted in the
images and the company's success,
depicted in the portfolio charts.

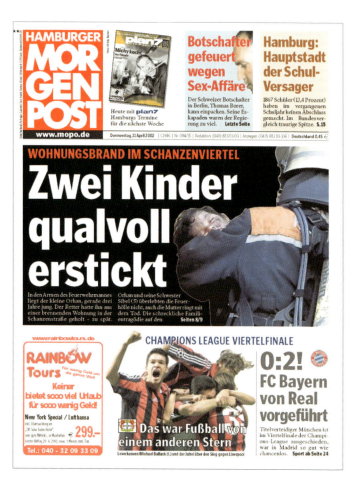

Not just for magazines: The placement of a headline or other type element over a photograph comes naturally to magazine designers but is more carefully calculated among newspaper editors. However, a large headline that is easy to read can complement a photograph, as we see on this front page of Germany's *Morgen Post*, the popular Hamburg daily. The image and the headline form a "mini poster" or magazine cover to separate the lead story from the rest.

pure design

NR. 1/2001 7,50 DM / 3,83 €
SFR 7,50 / ÖS 61,- / LFR 183,- / LIT 10.000,- / FF 35,- / DKR 44,- / ESC 1.050,- (CONT.) / NKR 47,- / PTAS 875,- / GBP 4,- / SKR 52,- / DR 2.000,- / HFL 11,- / BFR 183,- | C 81.893 F ISSN 0946-2198

ZEIT

DIE ZEIT

Das Magazin zum Thema COMPUTER

LERNEN MIT DEM COMPUTER

SURFEN STATT SEZIEREN
Tierleben retten: Wie angehende
Mediziner mit der Maus Frösche
präparieren

NÄCHSTE AUSFAHRT PHOENIX
Online zum Diplom: Virtuelle Unis
in den USA und in Südafrika

VERHEISSUNG INTERNET
Pro und Contra: Gehören Laptops
in den Schulranzen?

NIE DRAUSSEN, IMMER DRIN
Der PC als Fenster zur Welt:
Alex ist 16 und kann nur Kopf
und Arme bewegen

GROSSER SERVICE-TEIL
Die besten Lernprogramme
und Internet-Links für Schüler:
Von Star Wars bis Dr. Brain

PUNKTE

What a difference a subhead makes

Some stories need to run long. It is then that the designer works with the writer and/or editor to guarantee that the text will be reader friendly. This is done with subheads: those lines that provide a pause in the midst of the article, allowing for the writer to push the content, anticipating what is to come.

The effectiveness of subheads is unquestionable. Not only do they provide a visual break, but they also divide or outline the story for readers who scan texts.

Sometimes the subheads are the difference between a long article getting read or not. How can we use them effectively?

- Do not use mathematical formulas. Instead, place subheads in strategic points of the text, where they advance the story.

- Use a type size at least one point bigger than that utilized for the text of the story. A 9-point text would carry 10-point subheads.

- Allow some white space above the subhead to make them noticeable and to bring the eye and the finger of the reader to them. Nothing is worse than a "squeezed" subhead.

- Both serifs and sans serif fonts work well.

- Lowercase letters work better than all caps. ■

Drop caps: help or hindrance

How the eye moves across a page is an issue that editors, designers, and advertisers wish to know more about. While many studies have been conducted on the subject, the fact remains that we continue to design pages in ways that we personally think cause the reader to shift from "here to there."

One of the most popular approaches, of course, is the use of a large capital letter at the beginning of an article, which, when shown in the size equivalent of three or four lines of type, causes the eye to move right to where the text starts.

Used properly, drop caps can be effective eye-moving devices. However, used in excess, as in four or five during *one* article, they lose impact and become part of an "alphabet soup." Here are some drop-cap tips:

- Use initials at the beginning of articles, not with the rest of the article (subheads are better for breaking up a long article).

- Use initials in a size that does not drown out the headline, ideally, at the height of three lines of text.

- Do not use initials for every article on a page. Instead, use them to give the lead item on the page greater importance.

- Use drop caps functionally, not as decoration. ■

Case Study | TV Guide

The Problem: When *TV Guide* was looking to redesign, the editors weren't concerned about their logo, photography, or any glamourous stuff. The problem was that cable channels were multiplying, and the guide's trademark small pages were quickly beginning to resemble Sanskrit. They couldn't make the book any larger, because of their custom grocery store checkout boxes. So the grids had to be reworked, as did the "highlights" listings that ran alongside.

What we did: The highlights pages had traditionally had a "rolling log" design, simply column after column of entries. We remade these in a magazine format, with single-page features (right) interrupting the listings, allowing for a stronger editorial voice throughout.

On Video AND DVD

Elvis Presley DVDs (available now) The King rocks on with the DVD debuts of his most memorable films, including his hip-shaking available now) Sissy Spacek and Tom Wilkinson deserved their Oscar nominations for this keenly observed portrait of a New England couple coping with life after their son's murder. The superb acting makes the somber subject with life after their son's murder. The superb acting makes the somber subject compelling.

The Outer Limits: The w why Stephen ed this creepy

Original Series–Season I (DVD, available now) *Do not attempt to adjust the picture. We are controlling transmission....* These 32 classic epinever been better than in this uplifting true story about Jim Morris, a Texas high school teacher who achieves his lifelong dream of pitching in the major leagues—at the age of 35! You don't have to be a baseball fan to enjoy this feel-good family film.

Showtime (VHS and DVD, available now) Eddie Murphy and Robert De Niro ham it up in a contrived action-comedy about mismatched cops who are forced to team up on a reality-TV show. The self-spoofing stars manage to get some laughs, but this movie is no "48 HRS."

We Were Soldiers (VHS and DVD, available now) John Wayne would have felt right at home in this Vietnam War drama saluting family values and patriotism. Mel Gibson is commanding as an officer who leads his troops into a bloody battle in 1965 while wife Madeleine Stowe holds down the home front. —*Michael Scheinfeld*

Sunday

(TVL)-(75) **Beverly Hillbillies** 3230284
(USA)-(25) **Dead Zone (CC)** *1:00*907468
Johnny tries to save a young runaway.
[Time approximate.]
(VH1)-(45) **Rerun Show** 333352
(WGN)-(20) **Jerry Lewis Telethon** *21:00*
See Sun./Early Mon. 12 mid. Ch. 28/11.

11:30 (3) **American Masters (CC)** *1:30*96081
"Hitchcock, Selznick & the End of Hollywood"
charts the stormy seven-year (1939-46) collab-
oration between the fabled director and the pro-
ducer of "Gone with the Wind."
(8) **Sports Extra** 75739
(28)-(11) **Bucs Zone**—Pro Football 82710
(62)-(8) **Noticiero Univisión** 930449
(BET)-(65) **Lead Story**—Discussion 400623
(CAR)-(62) **Harvey Birdman, Attorney at Law
(CC)**—Cartoon 2573307
(COM)-(61) **Trigger Happy TV (CC)** 5314401
Debut: A series involving stunts played on
bystanders along the street. Dom Joly hosts.
(DIS)-(68) **Even Stevens (CC)** 864807
Louis participates in a school fund-raiser
called "nap for the needy." Shia LaBeouf.
(E!)-(37) **Anna Nicole** 925517
Anna Nicole goes to the dentist.
(H&G)-(57) **Extreme Homes** 2042178
A Frank Lloyd Wright-inspired house in Hawaii.
(HIS)-(64) **Basic Training (CC)** 2375246
(NIK)-(36) **Cheers (CC)**—Comedy 613517
(PLX)-(66) [M*★★] **Mr. Holland's Opus (CC)**
—Drama *2:25*68933642
(1995) Richard Dreyfuss's Oscar-nominated
performance guides this tale about a frustrated
composer who finds his calling in teaching.
(SUN)-(31) **Sportsman's Adventure** 59468
(TNN)-(53) **Real TV** 204401
(TVL)-(75) **Gilligan's Island** 7633265
(VH1)-(45) **Behind the Music (CC)** *2:00*
Aerosmith is profiled. 998951

11:35 (10) **Earth: Final Conflict (CC)** *1:00*
Acting on Howlyn's orders, Sandoval and Tate
set out to destroy an Atavus stasis chamber—
but are interrupted by Renee. In the ensuing
firefight, she saves a young Atavus. 8880772
(MAX)-(74) [M] **The Naked Detective (CC)**
—Thriller *1:25*72014913 Jim Gardiner.
(SHO)-(72) **Soul Food**—Drama *:55*77184438

11:45 (CAR)-(62) **Sealab 2021 (CC)** 92935975

11:50 (STZ)-(80) [M★] **Town & Country (CC)**
—Comedy *1:45*24724913 Warren Beatty.

Early Monday

Mid. (8) **Extra** *1:00*53918
(13) **Stargate SG-1 (CC)** *1:00*26802
(28)-(11) **Jerry Lewis Telethon** *18:30*
Co-hosts Ed McMahon, Wayne Brady, Bob
Zany, Norm Crosby, Cynthia Garrett and Jann
Carl join Lewis for the 37th annual fund-raiser

slated to appear: Billy Crystal, Patti LaBelle,
Chicago, Penn and Teller, Carrot Top.
(32)-(12) **George Michael Sports Machine**
503482
(38)-(6) **Mutant X** *1:00*4417208
(62)-(8) **Cuánto Vale el Show** *1:00*330550
(66)-(17) **Joel Osteen**—Religion 64531
(A&E)-(48) **Third Watch Marathon (CC)**
—Drama *4:00*906192
(APL)-(35) **Jeff Corwin Experience**
—Nature *1:00*7180005
(BET)-(65) **BET Inspiration**—Religion 541579
(BRV)-(54) [M★★] **Hamburger Hill**
—Drama *2:00*147802
(1987) Vietnam diary of a U.S. platoon's
assault on an NVA stronghold. Dylan McDer-
mott. Doc: Courtney Vance.
(CAR)-(62) **Aqua Teen Hunger Force (CC)**
—Cartoon 1648918
(CNB)-(33) **Kudlow & Cramer** *1:00*9252821
(CNN)-(40) **Larry King Weekend** *1:00*716376
(COM)-(61) **Insomniac with Dave Attell (CC)**
2939192
(CSP)-(99) **Commons Question Time** 965208
(DIS)-(68) **So Weird (CC)** 901937
(DSC)-(51) **Totally Out of Control (CC)**
—Documentary *1:00*415869

CLOSE UP

24 MARATHON (CC)
SUN./EARLY MON. 12 mid. (FX)-(39)

In Real Time FX airs all 24 episodes (back to back
the acclaimed drama's first season, which centers on
harrowing day in the life of Federal counterterrorism
Jack Bauer (Kiefer Sutherland).

This winning exercise in sustained tension earned
Emmy nominations, including nods for top drama and
actor. It follows, in real time, Bauer's efforts to save
lives of his wife (Leslie Hope), his daughter (Elisha
bert) and presidential candidate David Palmer (Denni
Haysbert). 24's
sequences and
plot twists nev
overwhelm its
acting, notably
of Haysbert
Penny Johnson
Jerald as Palm
wife. Victor Dra
Dennis Hopper
Sutherland Sarah Clarke.

What we did: Above, even single pages were interrupted by boxes, for contrast and a stronger editorial voice.

What we did: For the grids (right), we did type tests, deciding on a highly readable Interstate Condensed. Leading and tracking were adjusted to fit as much text as possible, while retaining legibility. Next, we looked at the page to see if there was unnecessary infor-mation taking up space. We minimized page headers and dropped folios (would you really use page numbers?). One important piece of information, the day header, was left large. But the real breakthrough was removing the vertical rules in each grid. While traditional, they are often unnecessary, since the content defines the verticals. This contributed white space, making the pages much more readable.

Friday

September 6, 2002

BROADCAST	8:00	8:30	9:00	9:30	10:00	10:30
3	Washington Week	Wall St. Week	Tampa Bay Week	McLaughlin Group	NOW with Bill Moyers	
8	Dateline NBC		Law & Order: Special Victims Unit		Law & Order: Special Victims Unit	
10	48 Hours		60 Minutes II		NFL Kick-Off Concert	
13	★ ★ Starship Troopers (1997)				News	News
16	Antiques Roadshow		Travels in Europe	Exper./America	Evening at Pops	
28 – 11	America's Funniest Home Videos		America's Funniest Home Videos		ABC News Special	
32 – 12	Sheena		BeastMaster		Jerry Springer	
38 – 6	Sabrina, Witch	Sabrina, Witch	Reba	Reba	Cheers	Cheers
44 – 4	★ The Glimmer Man (1996)				Frasier	Frasier
62 – 8	Salomé		Privilegio de Amar		Casos de la Vida Real: Edición Especial	
66 – 17	★ ★ Almost an Angel (1990)				Diagnosis Murder	

CABLE	8:00	8:30	9:00	9:30	10:00	10:30
A&E – 48	Biography		★ ★ ★ Serpico (1973)			
AMC – 22	★ ★ Midway (1976)				Cinema Secrets *	★ ★ ★ The Fury *
APL – 35	That's My Baby	That's My Baby	Hope Ranch (2002)			
BET – 65	To Be Announced				Comicview	
BRV – 54	★ ★ Les Miserables (1998)					
CAR – 62	Ed, Edd n Eddy	Time Squad	Courage Dog	Grim & Evil	Premiere Prem.	Whatever/Jones?
CMT – 58	Prime!		Austin City Limits		Top 20 Countdown	
CNB – 33	Kudlow & Cramer	Louis Rukeyser	Editorial Board		The News with Brian Williams	
CNN – 40	Connie Chung Tonight		Larry King Live		NewsNight with Aaron Brown	
COM – 61	Comic Remix	Lounge Lizards	Comedy Central	Comedy Central	Comedy Central	Comedy Central
CRT – 55	NYPD Blue		Forensic Files	Forensic Files	The System	
DIS – 68	Seventeen Again (2000)		Model Behavior (2000) *			
DSC – 51	Inside the White House		Future Guns		Curators of Crime	
E! – 37	TV Tales				Anna Nicole	Anna Nicole
ECL – 78	SportsCentury		College Football Classics (2001): Miami vs. Florida.			
ESN – 27	◄ College Football: Hawaii at BYU.				Baseball Tonight	Baseball
ES2 – 28	NFL Yearbook	Mohr Sports	Boxing: Lucas-Sheika (super middleweights).			
EWT – 46	World Over		Life Is Worth Living	Holy Land Rosary	Defending Life	Monsignor Clark
FAM – 52	★ ★ Bye Bye, Love (1995)				Alias	
FLX – 60	★ ★ Voyage of the Damned (1976)					★ ★ ★ Ladybird *
FNC – 67	O'Reilly Factor		Hannity & Colmes		On the Record with Greta Van Susteren	
FSN – 69	◄ Baseball: Rangers at Devil Rays.				Best Damn Sports Show Period	
FX – 39	◄ ★ ★ Just Cause (1995)				Married/Childrn	Married/Childrn

◄ Program started * Program starts within the half-hour.

(HIS) – 64 **Modern Marvels (CC)** *1:00* Examining security systems. 4564631
(LIF) – 38 **Intimate Portrait (CC)** *1:00* A profile of actress Patricia Richardson. 378322
(MSN) – 30 **Nachman—Discussion** *1:00* 1754186
(MTV) – 44 **Direct Effect** *1:00* 363490
(NIK) – 36 **Hey Arnold!—Cartoon** 412070
(PLX) – 66 **Night Gallery (CC)** *1:00* 4666083
(QVC) – 29 **Veronese Collection** *2:00* 6190877
(SUN) – 31 **To Be Announced** *1:00*
(TBS) – 23 **Friends (CC)—Comedy** 841693
(TCM) – 59 **Cinema Europe** *1:00* 4732631 The transition from silent films to talkies.
(TLC) – 34 **Daring Capers (CC)** *1:00* 617419 Included: a tunnel beneath the Berlin Wall.
(TNN) – 53 **Real TV** 533983
(TNT) – 26 **Law & Order** *1:00* 608761

(TRV) – 43 **Best of Hawaii** *1:00* 7840506 Authentic luaus, exciting adventures.
(TVF) – 56 **Sara's Secrets** 5357780
(TVL) – 75 **Beverly Hillbillies** 6797693
(USA) – 25 **JAG (CC)—Drama** *2:00* 374631 An admiral is accused of committing war crimes in Vietnam. Terry O'Quinn.
(VH1) – 45 **One Hit Wonders** 351341
(WGN) – 20 **Home Improvement (CC)** 184631

7:30 8 **Extra** 2457
10 **Jeopardy! (CC)—Game** 4693
13 **Drew Carey (CC)—Comedy** 6693 Conclusion. The guys try to free Drew from the psych ward.
16 **Jay Jay the Jet Plane (CC)** 2631
28 – 11 **Hollywood Squares (CC)** 96693
32 – 12 **Celebrity Justice** 21490

73

layout

HOW TO BUILD A PAGE

Page architecture

Architecture refers to how a designer uses the available space on the canvas of the page. It is defined by the numbers of columns used, the varieties available, and how text and photos blend on the page.

When it comes to page architecture, the front page sets the "mood" and gives the publication its distinctive personality. We all identify such newspapers as the *Frankfurter Allgemaine,* the *New York Times,* and the *Wall Street Journal* by their distinct vertical placement of elements.

These days, the *Times* sometimes deviates from the strict vertical layouts of yesteryear, with some front pages sporting multicolumn color photos, and the *Wall Street Journal* in Europe and Asia have redesigned to do likewise. However, these classic newspapers remain quite vertical in their approach to news placement.

Do readers sense that a vertical architecture lends a more "serious" aura to a page?

This question has not been scientifically tested, but it is dear to editors and publishers. They're all convinced that a serious newspaper is more vertical than horizontal.

Ultimately, it is the tone of the headline, the content of the page, and the overall look and feel of a newspaper that determines how it is perceived, not how the columns are displayed.

Let me add that excessive use of vertical columns leads to "tomb-stoning" (clashing of headlines), gray masses of type, and overall dullness.

As for the more contemporary horizontal placement, it is easier for headline writers and allows the editor and designer better opportunities to create page hierarchy. For instance, one can lead with a four-column headline, and then move to a measurement of fewer columns. Instantly, the page gains balance and contrast. In the end, content is still king and should dictate how page architecture is utilized. ∎

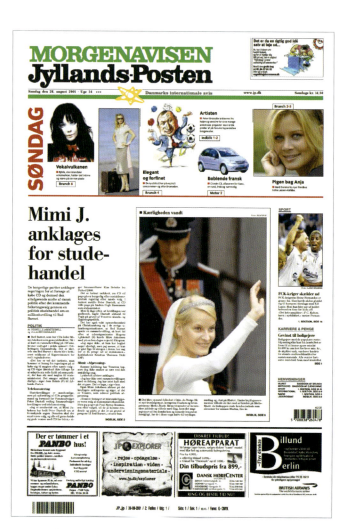

Designing with columns: Other than type, one constant element in newspapers and magazines is the column shape. Denmark's *Jyllands Posten* shows how the movement of columns can inject magic and help complement and contrast other structures, such as photographs, illustrations, and graphics. Sometimes the best "column" is the one that includes only white space.

Architecture and hierarchy: The international page of The *Wall Street Journal* was designed to accommodate tremendous amounts of different information. By distributing the material over the six-column space, with an anchoring spot for the world briefs to the left, we solved the problem and maintained a page that is attractive and easy to follow.

Systematic chaos

Editors are always a bit shocked when I say that I would like to put some systematic chaos on page one. Chaos has a negative connotation. But, like a pinch of pepper in soup, chaos, in small doses and carefully controlled, ads energy and zest to a publication. The front page is a mirror of what happened the past twenty-four hours. Chances are it was not an orderly fare of events. A front page that is dormant does not reflect this reality. So how does one provide systematic chaos?

- Avoid perfectly rectangular architecture. Modular design can be helpful on inside pages, but don't overapply it on the front.

- Wrap one major story around another one, allowing for two stories to be above the fold. Sometimes, in our efforts *not* to make headlines clash, we sacrifice energy and movement.

- Have one photograph dominate, and sprinkle the page with a few smaller photos (not too many.)

- Add a dash of light color where the reader least expects it, or add a story that the reader is not likely to expect on the page, and give it an italic headline.

- Mix serifs and sans serifs, preferably from within the same family of type.

- Create templates to "plan" systematic chaos. That is what makes it systematic: it is controlled, with a purpose, planned to be that way.

A place for everything, almost: Who says one cannot have attractive pages that are busy? The *Hamburg Morgen Post* shows that it can be done well. We kept the edgy, newsy, in-your-face approach to tabloid news, but organized it so that a sense of hierarchy and some order prevailed.

Content rhythm

The American composer Ira Gershwin wrote about what he called "fascinating rhythm." The idea applies to design. Too often editors put content into "baskets" from which they are not willing to deviate.

Observing reader behavior for decades now has taught me that readers are not on the same page, so to speak, as editors when it comes to "rhythm". In fact, they are on different pages, and following different rhythms. The sanctuary of hard news in one corner and soft news on the other is a myth created by editors. Mix them, and readers are happy.

In a modern publication this mixture is critical in keeping readers interested and stimulated.

So page two of a newspaper, for example, may have a column, or a soft feature, followed by a hard news item at the bottom, or vice versa.

For a reader, fascinating rhythm comes when editors make sure that monotony never sets in, and that, like life in general, each page reflects the ups and downs of the day. ■

Visual parallelism

Sometimes a page has all the right ingredients: good content, eye-catching photographs, good copy, and enticing headlines. But the page still looks boring, or, as one editor of a Scandinavian newspaper put it: "I think our page is monotonous."

In this case, the problem was that the designer constantly placed a vertical column of text on the far left-hand side of the page, then did the same on the far right of the page, creating "mirror images" that suffocated whatever good might be happening in the center of that page.

Perfectly balanced pages are not the most exciting ones. Create variety. Mix vertical and horizontal units. If the left side is a text-heavy column, make the right a series of briefs, with illustrations added. Visual variety provides excitement. ∎

Indexing

There are different ways a publication can use indexing: through promotional units for main stories to the inside, through a specific summary of highlights (the news that the reader *must* not miss inside), or through a directory of sections, that is, sports, classified advertising, opinion, and so forth. Readers appreciate a newspaper, magazine, or newsletter that is easy to navigate. It is with indexes and promotional units that color is used most effectively, to highlight key sections, or to guide the reader from one section to the next.

But do not create indexes to decorate a cover or page one, or to show off good photos or visuals. Good indexes give the front of the publication a sense of hierarchy. What do editors think the reader should read first, second, and third? If the reader only has ten minutes, what is *must* reading?

And if five more minutes become available, what should be next? Good indexing prioritizes content for the busy reader. ■

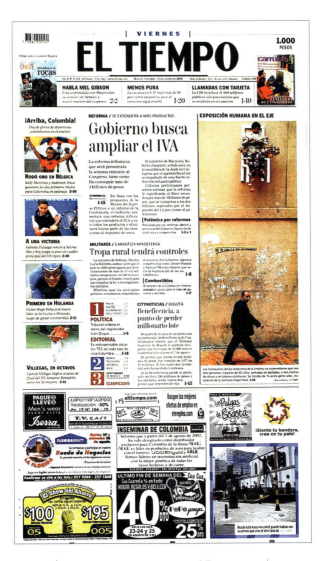

How the eyes move across a page

In 1984, my colleague Dr. Pegie Stark Adam and I conducted research on how the eyes move on the page at the Poynter Institute for Media Studies, which led to publication of "Eyes on the News" (www.poynter.org).

Results of that study are more current today than ever. Designers of all types of publications can benefit from this research. In the study we learned that:

- Readers enter a printed page through the largest image on the page, usually a photograph.

- After this, headlines are seen by the majority of readers.

- Captions under photographs are the third most frequently visited part of the page.

We learned that our best opportunities to grab the attention of readers are in these three areas. We learned that we must always have one dominant element on the page, three times bigger than any other visual element on that page. This is the reader's point of entry.

We also learned that headlines and photo captions are fantastic tools for adding new compelling information. ■

How the eyes move across a screen

The Stanford/Poynter research is the first known study of how readers read on the Web, conducted using Eye-Track technology. Here are a few highlights of the findings:

■ Users' eyes go first not to photographs or graphics, but to text. Briefs or captions are first. Next, they come back to photos or graphics, often not until they have returned to the first page after clicking away.

■ We learned that the designer's first chance to engage the reader is through text. We continue to see patterns in which text is sought out and skimmed or read.

Much research continues, and even though the Stanford/Poynter study indicates that text is preferred over photos, I attribute this to the fact that many news websites do not use photos properly, often copying the newspaper layout. As a result, photos are presented in a reduced format, and their impact is lost. An early study conducted at the Poynter Institute showed that photos were the first point of entry for print readers. Why? Because most of the time, papers publish dominant photos that command instant attention. When we reduce a photograph to the size of a postcard, impact disappears. However, if photos are presented separately, and sized appropriately, users will look to them as a key piece of the story. ■

Shapes of information

There is nothing complicated about the shapes, or modules, in which information may be presented on a page.

This applies equally to newspapers, magazines, brochures, and newsletters. Usually, a designer has a photograph or illustration, a headline, and text. Those are the basic components of the story-telling process. And if readers could have a dialog with designers, they would say that their preference is a simple one: photo or illus-tration, headline, and text

Following that model is not difficult to do, and it makes the most sense: the reader first looks at the photo to grab the first message of the story, then reads the headline, the caption, the subhead, and if interest remains, the text.

Two other shapes that are part of the same type of packaging are:

- *The U-shape:* With a horizontal headline across the page (let us say across six columns), the text forms the shape of the letter U around the photo or illustration.

- *The L-shape:* This is similar to above, but the text ends under the photo, without going up into a sixth column.

These shapes do the job well and should be part of every designer's *must-have* templates. ◼

Think U and L: As much as a designer may wish to imagine new shapes for presenting information on a page, the fact is that using the basic shapes of the letters U and L is still the best solution. We see here how these structures work for our projects with *Listin Diario* of the Dominican Republic, and *El Pais*, of Cali, Colombia. Shapes are part of the papers' style, adding visual continuity and permitting designers to spend more time in the selection of images than in the reinventing of new shapes.

Promos

Three ingredients of effective promos are: variety, brevity, and content. One of the most popular subjects of newsroom consternation is news promos (also known as refers or teasers) in the nameplate area of the front page. Newspapers with a high rate of street or rack sales are more likely to benefit from effective nameplate promos. On the other hand, some editors are convinced that a large headline on a major news story is the main thing that increases rack sales, while many circulation directors will swear that a colorful, active photo, placed entirely above the fold—not partially—is the way to boost sales. Here are three quick tips to consider when producing effective promos above, within, or immediately below the nameplate:

- Variation—of tone, texture, and even size and frequency—is important. If the promos look the same each day, readers become numb to them.

- The wording of promo elements is at least as important as accompanying visuals. In grabbing readers' attention, generic wording such as "Movie Reviews—See Section F" is not as effective as saying "Jurassic Park III: Too scary for kids? Story, photos in Section F."

- Brevity is best. Readers will spend just a second or two processing information in promos (also confirmed by our Eye-Track research). And visuals should be tightly cropped, easily recognizable images. Do not use crowded action photos from sporting events, or busy news photos. "Quick read" needs to be the order of the day. ■

What's inside: At both Madeira's (Portugal) *Diario de Noticias* and the Dominican Republic's *Listin Diario*, promos are effective because they are much more than just headlines. Each is a mini-summary of an interior story, more effective for scanners.

San Francisco's Hometown Newspaper

25¢
Inc. Tax

THURSDAY
June 20, 2002

▌**Warren Hinckle**

Lau fits the shirt, but not the job
Police chief's attire tells who he is; his actions tell what he cares about — and it's not fighting crime. **| SEE 7A**

The Examiner.

FBI SCRAMBLES FOR JULY 4TH TERROR

Acting on a hunch gleaned from al Qaeda captives at Gitmo, bureau orders its 56 field offices to mobilize for possible homeland terrorist attacks on Independence Day. **| SEE 13A**

▌**Air Travel**

Fat folks say two-seat rule is too much

Southwest Airlines says it will require large passengers to pay for two seats. Plus-sized passengers pound plan. **| SEE 4A**

▌**War on Terror**

U.S. troops to patrol in Philippines

Pentagon OKs sending 1,200 advisers in war with Islamic militants — raising concerns that U.S. will be drawn into another Vietnam. **| SEE 13A**

▌**Crime**

Lure of the streets leads to his death

A Bayview family struggles to understand their 19-year-old's life — and death — on Bayview's mean streets. **| SEE 6A**

▌**Interview**

A dark vision from Spielberg and Cruise

Hollywood heavyweights discuss their decidedly un-Hollywood "Minority Report." **| SEE 26A**

City's costly car craze

CITY HALL VEHICLE POOL
Authorized Pool Vehicles Only

San Francisco owns or leases about 2,000 cars, many of which are used by city employees for their personal commutes. Now, Supervisor Aaron Peskin is calling for a reform that would take the wheels off the money-guzzling deal. **| SEE 5A**

▌**Middle East**

Jerusalem stunned – 2nd bomb

An Israeli man is helped from the site of Wednesday's bombing — the city's second in two days. **| SEE 14A**

Attacks stall Bush's peace proposal | SEE 14A

Israeli tanks return to the West Bank | SEE 14A

Going after you: The *San Francisco Examiner* jumps out of the box and chases the reader down the street. Promos add to the chase. Notice the burgundy for top promos, as well as simply written headlines and images.

Klagenfurt, Sonntag, 12. Jänner 2003 www.kleinezeitung.at

KLEINE ZEITUNG

SPORT
Simon siegte bei WM
AACHEN. 2003 wird ein Drittel
aller Zigarettenpackungen mit
Hinweisen auf Gesundheiten
2003 wird ein Drittel aller
Zigaretten mit Hinwei. Seite 24

70 Kinder starben bei Horror-Crash

Pilotenfehler in 10.000 Meter Höhe: Zwei Flugzeuge kollidierten. Seite 24

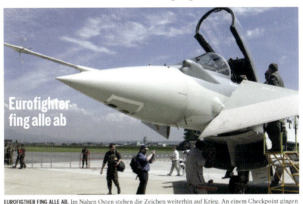

Eurofighter fing alle ab

EUROFIGTHER FING ALLE AB. Im Nahen Osten stehen die Zeichen weiterhin auf Krieg. An einem Checkpoint gingen gestern die Emotionen hoch, als ein israelischer Soldat einem palästinensischen Arzt die Durchreise verweiger-

Schulschluss: Jeder Fünfte hat Nachzipf
BRÜSSEL. Ab 2002 wird ein Drittel jeder
Zigarettenpackung mit Warnhinweisen
auf Gesundheitsgefahren verpflastert
sein. Das entschied ges-tern das EU-
Parlament. Auf der Vorderseite kann es
dann heißen: „Rauchen macht impo-
tent". Seite 24

Wirtschaft: Kein Aufschwung
WIEN. 2003 wird ein Drittel aller
Zigarettenpackungen mit Hin-
weisen auf Gesundheitsgefaller
Zigar ettenp ackunitsgefah ren
verpflgen mit Hinweisen auf Ge-
sundheitsgefahren verpflnweisit
Hisen auf Ges. Seite 24

Nr. 320 73 €-Cent Telefon 0 31 6/875-0 Österreichs meistgelesene Bundesländerzeitung. Unabhängig. HRK L3 – / Italien € 1.45 / Hdf 300 – / SrT 300 –

FOTOS: APA/GIANNI ARJVANSON GEPA PICTURES

Selling stories: Germany's *Kleine Zeitung* utilizes skyboxes and a left column of promos to pull readers in. They vary in shape and content every day to keep the reader alert.

Experimenting with ads

If there is one area where the Internet has left a mark on print, it is in advertising. The limited size of the screen affords designers and editors a small canvas for editorial and advertising elements. This cozy cohabitating has produced adventurous ad placements, which are giving rise to experimentation in publications, such as:

- *Wraparounds:* Some newspapers allow advertisers to buy a four-page wraparound, especially when a new product is introduced into the market. Some, like Colombia's highly respected leading daily *El Tiempo*, of Bogota, carried a L'Oreal shampoo ad around its first section, with no major disruption or complaints from readers.

- *Unusual shapes:* Ads are no longer limited to rectangles at the bottom of the page. When Compaq computers introduced a new line of products in Denmark, the largest circulation daily, *Jyllands-Posten,* accommodated ads for the computer maker in circular or triangular shapes, with news items surrounding the ads.

- *Silent ads:* Perhaps the most innovative, these ads appear in the midst of navigational devices, such as indexes or promo boxes. In this type of ad, the only message is a brand: Visa, MasterCard, and Nike. Seen mostly in German or Scandinavian newspapers right now, these will soon be extremely popular everywhere.

And so, in today's newspaper, all kinds of experimenting with ad positioning is key. Some ads appear at the top of the page, and not at the bottom; and, yes, the editorial content is placed directly under the large ad at the top (keep the depth as shallow as possible, please); other ads appear as islands, especially in the middle of large masses of text, as in stock listings or sports results.

We have only seen the beginning of experiments with ad positioning. The staircasing of ads may finally be a thing of the past. That is good news for designers, editors, and definitely readers. ■

Ads coming of age: The greatest experimentation with advertising positioning is taking place in Denmark. When we worked with the *Jyllands-Posten* team in Copenhagen, it was refreshing to be able to keep advertising away from the basement of the page and to use other unusual placements, as these three examples show. This is the future, the eventual integration of advertising and editorial content. Savvy readers know the difference between the two.

Classifieds

Classifieds usually appear at the end of the day's edition, a mass of small type that nobody pays much attention to—except readers. They eagerly await the classifieds to find that precious new job, house, car, new pet, or soul mate.

It once was rare to be asked even to look at the classified section during a redesign. However, these days, no project is complete without making efforts to improve this section. Where does one start?

- Make sure that the typography of the section harmonizes with (or is identical) to that of the rest the newspaper.

- Section headers should match the rest of the paper. It is useless to create a new "section header" for classifieds, when it appears between business and sports. Why create typographic cacophony?

- There must be a complete and easy-to-read navigator, an index that describes each content section of the classifieds and where to locate it, either by letter, number, or page number.

- Icons help make locating each area easier but are not the only way to achieve this. Sometimes clear use of type—words—does as well.

- Allow white space between categories. Readers search for information here and there and *do not* read an entire page.

- Select a font for the text of small ads that is very easy to read, since the reader will have to struggle enough to get to the information. ▪

A place for every category: Indexing is the key to a successfully designed classified page. In our work with The *Las Vegas Review Journal,* our designer Ed Hashey evaluated how the section was presented, looking for the best possible font to make the small type legible. The result is a vastly successful section that sells well, and still looks attractive.

Opinion pages

Traditionally, opinion pages are the last to get looked at in a redesign project. Yet, editorial/opinion pages are some of the strongest in terms of content; it is there that a newspaper exposes its soul, convinces its readers of what routes to follow in daily life.

In the redesign of the *San Jose Mercury News* the editors *really* wanted to update their opinion pages, to make them useful and attractive to younger readers. To achieve this, we allowed for horizontal placement of the editorial at the top of the page. For reasons that have to do with tradition, most newspapers run editorials vertically to the left. Eighty-five percent of all newspapers follow that model.

Yet readers know nothing about "set patterns" for editorial pages. They simply know that these are the newspaper's opinion pieces. To design editorial pages that set the pages apart:

- Use bolder fonts in conjunction with lighter ones.

- Use a photograph or illustration whenever possible.

- Inject quotes and highlights to attract scanning readers. Sometimes editorial headlines are abstract; a quote may be more specific.

- Write more direct headlines!

- Remember that if the "opinion" of the designer is to be included, it should be expressed through white space. ■

Inviting in the reader: For a proposed Spanish daily edition of the *Dallas Morning News*, we abandoned the editorial on the left, columns on the right, and text-driven architecture. Instead, illustration dominates the page, main editorial runs across the top of the page, and columns are short, allowing for white space.

Tabloids vs. broadsheets

As newspapers get smaller, and tabloids become more popular, some newspapers are attempting "tabloid layouts" within the larger frame of the page. This can be a good way to bring the excitement of tabloids to the broadsheet. When I redesigned the Swedish newspaper *Dagens Nyheter,* in Stockholm, we attempted to do just that, increasing the size of the headline, displaying a dominant photograph and using such tabloid techniques as accelerated use of color.

The same is true for Brunch, the new Sunday supplement of *Jyllands-Posten* (Copenhagen, Denmark), which uses a magazine-tabloid approach within the more expansive ten-column broadsheet. The result: very elephantine and eye-catching treatment of pages, with large and sometimes full-page photos, larger headlines, and generous white space to accommodate it all. Sometimes what you first see is not the ultimate reality. In the case of Brunch and other broadsheets that adopt tabloid visual qualities, the mixing of the two "realities" provides for an interesting look.

When designing tabloids, designers who are used to working with the broadsheet format should make allowances for the smaller canvas of the page. As we worked with the team of the *San Francisco Examiner* to carry out the conversion of that newspaper from a broadsheet to a tabloid, it was evident that many of those doing the layout were bringing "broadsheet" concepts to the pages of the tabloid. It was time for some quick tips:

- Tabloid page design involves not just one page at time, but two. Why? Well, as readers open the pages of the tabloid, they usually make a sweeping motion with their eyes from left to right, almost in a straight line at just about the middle of the page. Once they do that, which takes a few seconds, they usually start reading the page on the left.

- Broadsheet page design involves the canvas of a larger page, which the reader looks at from top to bottom, regardless of the page next to it.

- Knowing this, it is important that tabloid designers working with page two inquire what is going on next door, on page three. Try to avoid two headlines running into each other, especially in the same font, weight, or size. Also avoid having two equally sized photos too close to each other.

By the same token, if the emphasis on page two is a big, vertical photo, it will be better to have a horizontal photo on page three, and so forth. Contrast between two contiguous pages is important for the tabloid designer, and not so key to those working on broadsheets.

When we tell designers that tabloids require more energy, we also remind them that, because of the tips above, they are also more demanding in terms of communication with other designers in the team. The tabloid designer cannot work isolated from what others are doing, because the reader will grasp two pages as one, visually speaking. ■

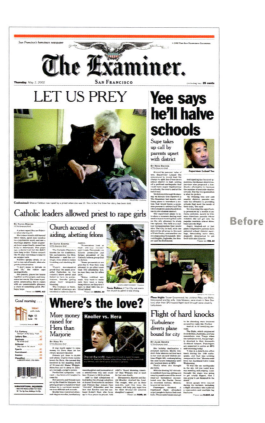

Before

When smaller is bigger: In 2002, the *San Francisco Examiner* switched formats from broadsheet to tabloid. In the process, new content was incorporated, along with bigger headlines, more vibrant photography, a color palette that depends on few, bright, strategically positioned hues, and navigation that makes travel through the paper faster and easier. We worked with the editors on content. Tabloids follow a different rhythm; we thought nothing of putting lighter content, such as a people/gossip column, on the same page with hard news. The modern newspaper, especially the tabloid, invites such combinations.

SAN FRANCISCO'S HOMETOWN NEWSPAPER

25¢
Inc. Tax

THURSDAY
July 18, 2002

The ✦ Examiner.

CITY SCHOOLS MUST REPORT TO MILITARY

President Bush's No Child Left Behind law forces high schools in San Francisco and throughout the nation to turn over seniors' names to Selective Service officials. | SEE 5A

▎Police

Videotaped Inglewood cop faces brutality charges

Officer Jeremy Morse, who was filmed slamming a teenage boy's head into a car during an arrest, will surrender today. His attorney says the officer used "necessary" force. | SEE 12A

▎AIDS/HIV

HIV-positive puppet is no Muppet

Lawmakers alarmed by the thought of a South African Muppet with HIV should meet Natalie. She's poz, she's cool and she's here in California. | SEE 5A

Your taxes at play

Congress probes $38,000 in strip-club charges on Army credit cards | SEE 15A

AP PHOTO

▎Cinema

Castro Theatre fetes its 80th year

The City's grand dame of movie-going celebrates its birthday tonight in grand style, with live music and a Busby Berkeley feature. | SEE 28A

EXAMINER FILE PHOTO

▎Student Clash

No charges, lots of anger at S.F. State

Israel and Palestinian backers stew after DA's decision. | SEE 6A

▎Crime

Was Texas nurse angel of death?

Former nurse charged in four killings — 20 other deaths may be investigated. | SEE 14A

▎Middle East

Tel Aviv bloodied by 2 bombers

Coordinated suicide attacks near cafe and theater kill five, injure more than 40. | SEE 16A

▎Oops

Drugs land Jeb Bush's kid in the slammer

Noelle Bush, daughter of Florida governor, locked up for possession while under court-ordered treatment. | SEE 14A

After

Relationships between items

Perhaps one of the most important tasks of the designer, whether for print or Web design, is to make sure that items that are some-how connected *show* that connection. Many times, in their efforts to keep things modular, designers forget to use techniques that empha-size relationships. Here are the best ways to ensure that this is accomplished:

- If a short item is related to a major piece, box the small item, but not in a full box, allowing an opening to establish that the two items are related.

- Place the related item, if very short, in the midst of the text of the longer article. Be careful not to make the reader jump too deeply before continuing the text.

- Use a color tint to highlight the related article.

- Always let the secondary, related item be under the coverage of the headline of the main article.

- Do not use heavy borders around the smaller related item.

- Whatever technique you use, make sure that readers do not have to second-guess your intentions, and that they see the established relationship in seconds. This is all the time they have! ■

Finger reading

Don't let the size of the so-called agate (type set 6 points or smaller) fool you. When it comes to heavy traffic and high visibility, the content that is usually set in small type plays an important role.

Consider what your newspaper would be without sports results, and start counting the complaints you would get from business people if you stopped running stock listings. How many readers decide to visit a restaurant or museum after they see it mentioned, yes, in very small type?

I refer to all these areas of newspaper and magazines as "finger reading." Readers tend to run their finger over the page when they search out these items, something they don't do when reading a narrative set in 8 or 10 point. Fingers and eyes are in unison, doing the moving.

Here are some tips for designing them effectively:

■ Always select the most legible typeface; sans serifs do better than serifs. For the *Wall Street Journal* we picked Retina, but many other faces do just as well.

■ Pay attention to category breakers, and make them slightly larger, and bolder, and maybe set in all capital letters. ■

To box or not to box

When the first newly redesigned edition of the *Wall Street Journal* appeared, one unexpected question became a constant in interviews, presentations, and seminars: Are boxes back?

Well, did they ever disappear? That seems to be a more appropriate question. True, boxes, which have traditionally been used to separate articles on a page, or to highlight an item to which editors wish to call attention were not used as frequently today as they were in the 1940s and 50s. However, boxes are tools that magazine and newspaper editors and designers can use functionally. They are not trendy or whimsical decorations.

Boxes should be part of every publication's design strategy. Here are some tips for using boxes:

- Determine from the start what type of articles will carry a box. (I recommend boxes for shorter, not longer, pieces; to set off sidebars or related articles that appear within a text package; and to isolate a photo story treatment, when the photo is not accompanied by a story).

- Use very thin borders around boxes. Do not call attention to the box itself with thick borders. Instead, create a box that delineates territory on the page, without overtaking it.

- Allow white space between the border of the box and the contents of it. Do not run photos or text right into the box.

- Sometimes use a thicker rule at the top or bottom of box, but never on the sides. The designer's task is to make sure that the box blends well with other elements of the page. Boxes are intended to offer boundaries, not to isolate themselves from other items on the page.

- Boxing an entire page should be reserved for one-topic items, long reportages, or photo essays. In most cases, it is best to go with an open page, without borders; but discretion and attention to the special content of the page are key.

Boxes are not back. They never left. They are, and always will be, a fantastically useful tool to make the reader's journey through a page faster and more orderly. ■

Navigation

Navigation is not limited to indexes and promo boxes on page one. It continues through every page of the newspaper. Labels do that job best. Page labels appear in three categories, each representing a level of hierarchy.

- The section front label appears as a large, prominent element to signal the start of a new section. The label resembles what is used on page one, with similar elements such as color rules, navigational boxes, and typography.

- The subsection label appears inside a section, signaling an important shift to a topic worthy of major consideration. For instance when a newspaper puts financial news on the back of the sports section, the financial news label should not be as large as what is on the section front, but it should be larger than a normal page label.

- The inside-page label appears on most pages of the newspaper. It should not be too large but also not so small as to lack functionality—30 to 36 points is a good size. It is important for each page to carry a label. It can be a combined label—such as "News/Features." The more specific, the better. "Politics" is better than "News." "Health/Fitness" is better than "Features." ■

pro**active**

Professional people

Programs aimed at aspiring auto dealers

Ford Motor Co. and Arizona State University (ASU) College of Business have announced related development programs for minority automotive retailers.

Ford's Automotive Dealership Education Program for Minorities (ADEPM) is a five-year, post-graduate training program managed by the company's Minority Dealer Operations organization. The program is designed to provide minorities with the skills necessary to become dealership owners and operators.

The ASU's Certificate in Dealership Management is a new option for undergraduates pursuing a degree in business.

The program is open to all business students, but it is meant to attract minorities. Minority graduates of the program will be offered entrance to ADEPM.

The ASU program includes a dealership management course, seminars, and industry internships. Management and marketing courses are tailored to auto retailing. The first group of ASU students to enroll in the program began studies in January.

Minority graduates of the Certificate in Dealership Management program who are accepted to ADEPM will earn what Ford terms a "mini MBA," hold dealership management positions, and then attain certification from the National Automotive Dealers Association. Graduates are eligible for Ford's dealer development programs.

We welcome your submissions.
Contact Senior Editor
Tim Dougherty
(tim.dougherty@hbinc.com;
fax 805-964-6139).

Carmen Cantor has been named Hispanic outreach coordinator for the U.S. Department of State. In addition to attending job fairs and visiting universities, she works with organizations such as the National Association of Hispanic MBAs and the National Association of Hispanic Federal Executives. Previously, Ms. Cantor managed the U.S. Postal Service's national women's program in Washington, D.C., and served as the Postal Service's Hispanic program specialist in Central Florida.

Sergio Pedroza has been named director of community relations for the Tucson Sidewinders, a minor league affiliate of the Arizona Diamondbacks baseball team. Mr. Pedroza previously produced and directed Spanish-language telecasts of Diamondbacks games and has served as a color commentator for Spanish-language cable broadcasts

of Phoenix Suns basketball games. He has held management and on-air talent positions with Univisión, Telemundo, CBS, ABC, and National Public Radio affiliates in Arizona and California.

Luis A. Colón has been named director of strategic and business planning for Source One Management Inc. He is responsible for developing and implementing the Denver-based organization's strategic and operating plans. Previously, Mr. Colón worked as a chemical engineer at Eli Lilly & Co. and in various consulting capacities at A.T. Kearney, PricewaterhouseCoopers, and XOR Inc. His numerous professional honors include a 2000 National Society of Hispanic MBAs Brillante Award for contributions in the areas of executive leadership and chapter development.

Armando Martinez has been appointed vice-president

of sales for Goya Foods. Spanning more than 20 years, Mr. Martinez's Goya career has included stints as salesman, sales supervisor, key accounts manager, and sales manager. He is based in Florida. Founded in 1936, Goya Foods also has manufacturing and distribution centers in New Jersey, New York, Illinois, Massachusetts, Texas, California, Puerto Rico, the Dominican Republic, and Spain.

Darden Restaurants Inc., owner and operator of Red Lobster, Olive Garden, Bahama Breeze, and Smokey Bones BBQ Sports Bar restaurants, has promoted **Dick Rivera** to vice-chairman. Formerly the president of Red

Lobster restaurants, he will now oversee Red Lobster and Bahama Breeze operations as well as real estate development at Darden. He was named one of the country's 100 Most Influential Hispanics by **Hispanic Business** magazine in 2000.

While the number of **MINORITY INTERNS** in newspaper newsrooms has declined, their percentage among all interns has increased to **31.1 PERCENT** from **29.0 PERCENT** last year — the first significant percentage increase since 1996.

Last year, **422 NEWSPAPERS (44 PERCENT)** reported having no **MINORITY JOURNALISTS.** This year the number rose to **431, or 45 PERCENT.**

Minorities account for **9.7 PERCENT** of the total number of **SUPERVISORS** in newspaper newsrooms.

Source: The American Society of Newspaper Editors

Navigation: *Hispanic Business* magazine employs large labels and healthy amounts of white space on every interior page, helping busy readers know instantly where they are.

Labels: In our design of *MOM*, a magazine for new mothers, our designer Theresa Kral used bold, color-coded blocks to guide the reader through the magazine. In focus group after focus group, we've seen that even loyal readers of publications have no idea of sections or how the magazine is broken up. Simple, crystal-clear navigation is key for these distracted readers.

Urlaub

Wo die wilden Kerle fahren

Schwere Jungs – kleine Kriminologen

WELLNESS-WOCHENENDE IM SPREEWALD

Skiferien! Thomas hat heute gebucht.

15 Minuten (die viertelstunde, die meistens fehlt)

KLEINKINDER

Vorsichtshalber auf die Knie

In einer Viertelstunde sehen Sie die Wohnung mit anderen Augen

Sofort reagieren

→ DER 15-MINUTEN-TRICK »Vor wichtigen Terminen plane ich eine Viertelstunde ein, um einmal zügig um den Block zu gehen. Das gibt mir vor Präsentationen Ruhe und hilft mir, meine Gedanken zu ordnen. Außerdem tut mir die frische Luft gut, da ich meistens in klimatisierten Räumen bin. Nach so einer kurzen Auszeit bin ich wieder fit und konzentriert bei der Sache.«
THERESA KRAL, ART DIRECTORIN VON MEIN UND SENIOR DESIGNERIN, MARIO GARCIA DESIGN HAMBURG

Volume

In design, we all apply volume to how we present a page. Sometimes the volume is loud; sometimes it is comfortable, sometimes it is a whisper. There is a place for all three. However, like rhythm, volume should be carefully calculated, and not all sections of a publication should have the same volume. Where does one apply it?

- Determining the size and boldness of headlines is the first step. Since there are more headlines than anything else set in large type on a page, it is here that we set the tone. Very big and very bold headlines convey force, loudness and presence.

- Determining the size, color, and thickness of headers at the top of pages is next. When one uses a 230-point font for the word *Entertainment,* and crowns the page with it, then the volume for the page is set. Nothing has any chance of competing with the heaviness of the top of the page. In this case, one obviously unimportant word has drowned out the sound of the rest of the page.

- Next we look at the size of photographs. When a photo is too large, too dark, or too colorful, the elements around it suffer.

Play your pages as you would your own radio, TV, or CD player: not too loud, not too soft, just enough to get the message across, appropriate to the mood and situation. ■

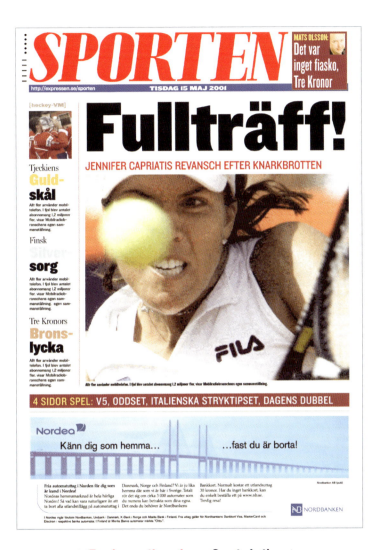

Turning up the volume: Sports is the right section of the paper to turn the volume up. Big headlines, big photographs, and other graphic strategies help make a little noise on the page. *Expressen*, the Stockholm daily, requires a level-ten volume on each of its pages, starting with page one.

The look of North America

Newspaper designers worldwide watch North American newspapers, especially the dailies, with great interest.

It was the American newspaper that first emphasized "makeup" in the 1950s, when type foundries such as Morganthaler and Linotype published newsletters and special reports on page layout to promote their newly created alphabets. American professor Edmund C. Arnold with his legendary Arnold Axioms—such as "functionalism over decoration"—emerged as one of the earliest gurus in the field. And American universities were among the first to introduce newspaper design as an academic discipline in journalism schools.

All of these are reasons why the North American newspaper has gained a reputation for being design conscious. And, truly, during the 1970s and early 1980s, when color was first introduced to a vast number of dailies, one could perceive a real sense of style and design experimentation. With color came new ways of looking at everything from typographic use for headlines and text, to better organization of content to clearer labels.

Then, sadly, a uniformity overtook the market. Newspapers in different parts of the country adopted the same color palettes, regardless of their surroundings. Color weather maps dominated; promo boxes appeared on papers with barely enough pages to warrant them. With few exceptions, newspapers remained in that

mold into the early part of the 1990s. Finally, during the last five years, some have begun to return to their roots, capturing elements of their past, such as a symbol for a logo, a certain color line, or a vertical navigator for the front page.

Undoubtedly, the United States is still the place to turn to if one wishes to see well-designed newspapers: the *New York Times* (especially the Sunday edition); the *Philadelphia Inquirer;* the *Minneapolis Star Tribune;* the *Wall Street Journal* (see *Weekend Journal);* the *Atlanta Constitution* (index page, Internet sections); the *Dallas Morning News* (newly redesigned, modern, crisp, but looking very much like a major city newspaper should); the *Charlotte Observer* (showing that a medium-size newspaper can make photos and text coexist).

Further north, the Canadians have created some top-of-the-line newspapers with design that is among the best in the world. Standouts are the *National Post* (past and present meet in a new newspaper) and the *Globe and Mail* (great typographic touches).

A newly inventive period for the design of North American newspapers is due soon. Hopefully this new era will usher in an openness to smaller formats, more functional use of indexes and navigation, and greater experimentation with advertising positioning. ∎

The look of Europe

I am always fascinated by how much newspapers look alike globally, but even more surprised by the differences, usually accentuated by touches that are not immediately obvious. As we look through a newspaper vending kiosk of any major city in the world, subtleties become clear. The word *variety* best describes European papers.

In the United Kingdom, we have the icon of what boulevard newspapers are all about, represented by such tabloids as the *Sun* and the *Daily Mail.* But there are also the classic models: the *Times* and the *Scotsman,* along with more contemporary examples such as the *Independent* and the *Guardian,* both a bit dated right now.

For the most part, Scandinavian newspaper designers respect typography and white space. Color reproduction is fantastic, along with the use of large images. From Norway to Denmark, and especially in Sweden, artistic precision and functionalism define the papers.

Although there has been relatively little innovation in Spanish newspapers in the past two years, they are, no doubt, among the best-designed newspapers in the world. The fresh air that came to Spain following the Franco era manifested itself well in the creation of newspapers that are models for the rest of the world, not only visually but editorially.

With very few exceptions, such as *Le Monde* and *Libration* of Paris and *Midi Libre* of Montpellier, I am always surprised by how poorly designed most French newspapers are. It is surprising because this is a country where design is always spelled with a capital D—in magazines, fashion, home accessories, and so on. But not newspapers (though it is never too late.)

Italian newspapers are not necessarily the most attractive, but they are heavily caffeinated, strong, and bold.

Not too far behind in energy and typographic passion are Greek newspapers, which are attractive, somewhat chaotic, and often carry great political cartoons, sometimes on the front page.

And the top prize in the category of uncontrolled chaos, with over-the-top boldness and passion, goes to the Turkish newspapers. They are truly among the most colorful birds on the continent! ∎

The look of Asia

The Asian newspapers are a good study of how historical influences can become a trademark of the look and feel of publications. Published in a variety of languages, including English, Asian newspapers tend to be bold, aggressive, spirited, and colorful. Those published in English tend to imitate newspapers from the United Kingdom more than those from the United States.

My first work in Asia was to create a newspaper in Singapore, the *New Paper*. Now thirteen years old, it is still as interesting and colorful as it was those few weeks when it first hit the street. Many critics were amazed that such a youth-oriented newspaper could do well in its market, attracting more than young readers.

The *New Paper* characterized Asian newspapers generally in its ability to be adventurous, to branch out, and do things differently. The front page could be a poster one day and more text driven the next; photographs could extend across two pages, and headlines were considered small at 86 point.

What distinguishes Asian newspapers from their counterparts in Europe and the Americas are:

■ Bolder headlines, narrower columns (for the broadsheets), more congested inside pages (for the tabloids), and louder color palettes (even for the more serious ones).

- More experimentation with advertising placement: starting on page one, around the logo of the newspaper, as floating islands, or in the middle of a page surrounding the ad with text

- Greater emphasis on coverage for young readers. For even the smallest regional Asian newspaper, a effort is made to attract young readers, and, with much success.

With the English-language newspapers, progress has been slower. While newspapers in the U.K. have redesigned themselves to be more organized, with better navigation, and superior use of photographs, their Asian counterparts continue to adhere to models of the British press of the 1960s and 1970s: mixing column widths on those broadsheets, utilizing far too many small photos on a page, and mixing type fonts. I have to include here some of the daily newspapers from Australia and New Zealand, which, although improved in terms of design over the past ten years, continue to be throwbacks to the golden era of the British broadsheet: too much, too cluttered, too "in your face."

Just like we turn to European newspapers for some of the best use of typography, or U.S. dailies for their excellent photojournalism, and to Latin American newspapers for their superb use of illustrations, we turn to Asian newspapers for their sense of spirit that is instantly transmitted, right on the front page. ■

The look of South America

If you could use one word to describe Latin American newspaper, it would be *creative*. So it is no surprise to see so many Latin American newspapers among the top winners in international design contests. Countries with the best dailies to watch for their design are Argentina, Brazil, Colombia, Mexico, and the Dominican Republic.

In 1984, Roger Black and I collaborated on a remake of the Mexican daily *Novedades,* taking it from a nine-column, black-and-white, text-driven broadsheet, to one of the earliest examples of a "tabloid" or magazine-style layout in newspapers. We increased the size of the photos and introduced a strong sans serif for headlines, accompanied by the classical Caslon, *mixing* them on the page. Much good has happened in Mexican newspaper design since then, and such dailies as *Reforma,* or Monterrey's *El Norte,* are among the best designed newspapers in the world, truly "Mexican" in their approach to art and illustration.

Distinct, too, are the newspapers of Brazil, with their front pages that serve entirely as navigation tools to the inside. Color palettes here are as bright as the colors on the facades of Rio's houses and, in many cases, as busy as its stadium during a World Cup match. Few newspapers anywhere carry the high level of illustrations that these dailies do. Standouts are: *Folha de Sao Pãulo, O Globo, Correio Brasilense, Zero Hora, O Povo,* and *A Gazeta.* One of the latest entries is *Agora,* a broadsheet with a tabloid feel, in populous São Paulo.

The rest of South America offers a variety of visually appealing broadsheets. *El Tiempo* of Colombia must be studied for its use of an unorthodox three-section distribution, where sports and economic news share a section cover! In Peru, *El Comercio* has always maintained a classic look, but one that is updated regularly. *El Comercio* of Ecuador is similar, with great use of informational graphics.

It is the Argentinean newspapers where one sees constant experimentation with color, graphics, story structuring, and illustration. *La Nación* and *Clarin* are excellent examples, but the provinces offer the most distinct uses of color and illustration, with *La Gaceta*, *La Voz del Interior*, *Uno*, *La Nueva Provincia,* and *El Liberal*.

The Caribbean is full of colorful dailies. In the Dominican Republic check *Listin Diario, El Siglo,* and *Ultima Hora*. In Puerto Rico, *El Nuevo Idea* is one of the most successful experiments in a tabloid format. Central Americans like tabloids, and many visually appealing ones abound. El Salvador's *Prensa Libre* and *Diario de Hoy* are the best.

One does not have to know Spanish to get ideas and draw inspirations, all quite abundant here!

Spanning the globe: Color, photography, typography, story structure, and size all change according to culture and climate. Some standouts from around the world: The *Dallas Morning News* (North America), *Handelsblatt*, Germany (Europe), The *New Paper*, Singapore (Asia), and *La Gaceta*, Tucuman, Argentina (Latin America.)

Publications of the future

The publications of the year 2020 will:

- Be small. Readers of all ages prefer small formats in magazines and newspapers.

- Be linked to electronic media, such as websites, CD components, and so on.

- Have color on every page, in photography and on highlighted texts.

- Include effective navigational devices to move the reader inside, and to guide him or her to the publication's website

- Be minimalist in style. The more screens fill up with buttons, gadgets, and more and content bits, the more print will do the opposite.

- Have more white space, bigger and fewer photos, and have a simple, skeletal, accessible look. From gutters to space between lines of headlines and text, everything will be more open.

- Make advertising a top priority. Especially on websites, advertising will become more prominent than it has ever been in print, more powerful, and full of visual impact. As a generation of Web users grows, so will the role of advertising in printed matter. We have not even seen the tip of the iceberg in this area. ■

NEWSPAPER/NEWSLINE/NEWSWEEK

2020

american press institute | 11690 | sunrise | valley drive | reston | virginia | 20191 - 1498 | www.desing2020.com

report news

A nights at the movies in the cinema

CHARACTERS the traditional wisdom used to be that when the weather was good, the movies were bad. After all, why would somone sit in a darkened room for two hours when they could be outside catching the rays and hanging out in place to be seen? It soon became apparent, however, that if nobody was releasing any good pictures during the hottest summer mounths, these year. **SURPRISING** the traditional wisdom used to be that when the weather was good, the movies were bad. After all, why would somone sit in a darkened room for two hours when they could be outside catching the rays and hanging out in place to be seen? It soon became apparent, however, that if nobody was releasing any good pictures during the hottest summer. **PULP-ERA** the traditional wisdom used to be that when the weather was good, the movies were bad. After all, why would somone sit in a darkened room for two hours when they could be outside catching the rays and hanging out in place to be seen? It soon became apparent, however, that if nobody was releasing any good pictures during the hottest summer mounths, these year. **DREAMS** the traditional wisdom used to be that when the weather was good, the movies were bad. After all, why would somone sit in a darkened.

North Carolina prepares for the storm's return

Backtracking, weaker Dennis divides island

What's on across the huricane Forecasters said Dennis would probably linger for days off the coast, ruining at least the start of the Labor Day weekend, after battering the coastline last Monday headed out to sea. page 4

on the net

GOLDEN GIRL / Gwyneth Paltrow is blessed with the Middas Touch/ www.design2020.com/fam

ARTS AND EVENTS / what's on across the USA art this season/ www.design2020.com/fam

city&state

No calm voice spoke over her baby's cries
page 4

the nation

Some blame sabotage for oil spill disaster
page 6

culture

Assaults, fires cloud future of Woodstock

page 12

the world

U.S. wants accounting of Russia financial aid
page 20

More color for sure: When the American Press Institute invited a group of designers to gather and propose newspaper models of the future, I worked with my Buenos Aires team, headed by Rodrigo Fino and Paula Ripoll, on our vision for a small-format daily (8.5 x 11 or A4). We used color everywhere, including in typographic treatments, and a good interplay of longer and shorter texts.

Case Study | The Wall Street Journal

The Challenge: The *Wall Street Journal* is the epitome of what a newspaper should look like. As a professor at Syracuse, I began each semester by holding up a copy of the paper and asking my eager students to redesign it. It isn't a surprise that the students tried to make it "modern" by placing a photograph on page one. The most daring designed a new color logo, but the wisest students would effect subtle changes, using brushes, light colors, and thin strokes. In these cases, the design played in the choir, while the texts and the content were the protagonists. In 1999 I began to redesign the international editions in Europe and Asia. The work was completed successfully, with the introduction of color and photography in both editions. Next, it was time to work with the American "mothership" version. This was a more challenging task: there were more pages and many more (mostly conservative) readers. From the beginning, the redesign was a collaborative effort between Garcia Media and The *Journal* team, headed by Joanne Lipman, deputy managing editor, and Joe Dizney, art director.

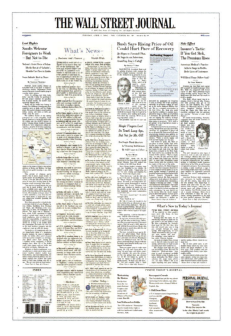

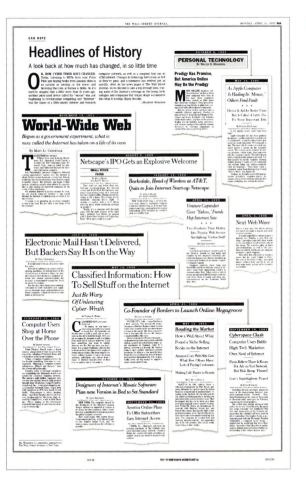

What we did: As if researching to write a novel or screenplay, the designers and I engaged in visual archaeology, studying issues from the 1920s through the 1950s. We discovered visual motifs, story structures, and storytelling that played a major part in the redesign.

What we did: We started by developing story structures to facilitate hierarchy through the pages: each story was composed of specific elements, depending on placement and importance. This helped to move the reader from story to story, and page to page.

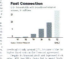

What we did: Once we had established story structures, we concentrated on page architecture, moving away from a rigid, six-column format, and introducing some five-column formats for section fronts.

THE WALL STREET JOURNAL

THE WALL STREET JOURNAL REPORTS.

© 2002 Dow Jones & Company, Inc. All Rights Reserved.

MONDAY, APRIL 15, 2002 R1

E·COMMERCE

The Price We Pay

More Web sites are charging
consumers for information
that once cost nothing.
Now companies are waiting
to find out: Will it stick?

By Mylene Mangalindan
PAGE 6

**WHERE DID THAT
COME FROM?**
Pop-up ads may be
intrusive and annoying.
But, as Joshua Rosenbaum
reports, they're here to stay.
PAGE 8

KEEP IT SIMPLE
Luxury retailers think
glitz sells on the Web.
Ann Zimmerman
discovered it doesn't.
PAGE 10

**DETAILS, DETAILS,
DETAILS**
Mitchel Benson uncovers
the secret for making a
mom-and-pop business
an online success
PAGE 12

RALLYING THE TROOPS
The Web has become a must
tool for political lobbyists.
Michael Totty shows what
does—and doesn't—work
PAGE 13

COURT BATTLE
Who sets the rules for
cyberspace? Rob Gavin
explains why it may
be Californians.
PAGE 13

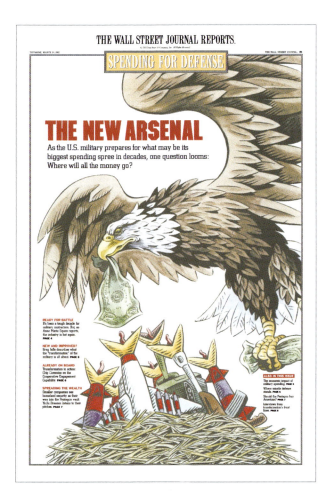

What we did: A basic foundation of the redesign was the introduction of a color palette. We made sure that when color appeared on a page, it was sophisticated and elegant. We used a few subtle colors consistently and repeatedly, including mint green, sky blue, and soft champagne.

What we did: A refined redrawing of the Scotch Roman typeface gave the new *Journal* a look that—although new and modern—did not take away from the tradition of the paper. An avid reader would still recognize his reliable paper in the newly redesigned version.

What we did: Our main goal was to preserve that which is genuinely and uniquely The *Wall Street Journal*. At the same time, we introduced modern elements such as better navigation, including a new panel on page one to promote interior stories. Now these new elements have become part of the *Journal's* identity for future readers.

color

Lots of color

If readers were to hand their editors a wish list, it would probably have *color* printed in big caps, each letter in a different hue.

The publication of today uses color to communicate, to energize the canvas, to attract the eye, to move it from here to there, and, ultimately, to leave an impression, ephemeral as it may be.

Color, however, is not only an aesthetic component; its use is ruled by optical perceptions that border on the scientific, and by symbolic ones that have more to do with culture and environment. Assigning color to a page, to the cover of a book, or to a website screen requires consideration of both. Three important characteristics of color are movement, temperature, and symbolism.

- *Movement:* Some colors—red and yellow for example—move forward on the page, grabbing readers by the lapel and pulling them in. Blue and gray, on the other hand, are flatter, emphasizing less motion.

- *Temperature:* Some colors are hot or warm, others are cool or cold. Content dictates what to use, but so does culture.

- *Symbolism:* Designers and editors know very well the passions that certain colors can evoke; fervent sports fans would not forgive a sports editor who painted a page with the rival team's color. It could be a costly accident. ■

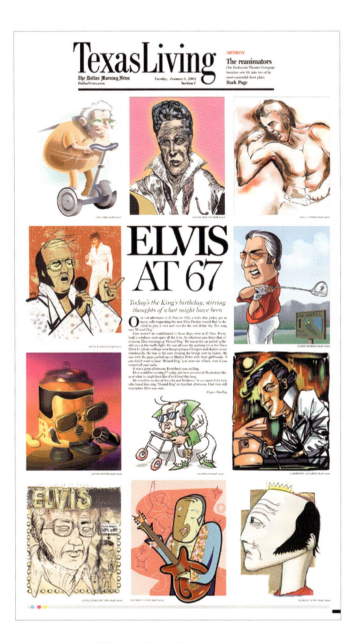

Where color is king: A *Dallas Morning News* story, where color tells the story.

Color research

Color research abounds, not only for the specifics of publication design, but also for applications in interior design, set decorating, hospital interiors, even building facades. The Poynter Institute for Media Studies has been a pioneer in the research of color and how readers react to it. Some discoveries of the research, available through www.Poynter.org, were:

- Readers *do* like color in their publications. However, color alone will not make a page more appealing: good content does.

- Readers enter each page through a dominant photograph, illustration, or other visual image, whether it is in color or black and white. Size and placement are more important determinants of point of entry than color. Focus groups do show that a large image in a bright, forward color is the ultimate way to get a reader on to the page.

- Color backgrounds are effective in drawing attention to the subject of a box, for example. However, it is best to use background colors in small areas: not too tall, not too wide.

- Colorizing type can be effective, but color works best on sans serif fonts, where legibility is greater. ■

Color headlines

Every designer and/or editor I have met has his or her own opinion on the subject of color headlines. And so do I, of course.

My preference is for headlines in black, 99 percent of the time. In the days before newspapers could reproduce beautiful color through photographs and illustrations, the occasional headline in color added a bit of visual excitement to the page.

However, today we can achieve colorful pages without colorizing headlines.

True, feature pages may benefit from a touch of color in a headline, but more often, a page can go the extra mile with just good color images, and a nice, big black headline. ■

White space

More often than not, after a redesign is complete, readers think the publication is printed on better paper. This, of course, is rarely the case. What has changed is that white space has been incorporated, thus giving an impression of a cleaner environment.

White space is important. Like punctuation in a sentence, it allows thoughts to flow without running into each other. It is no longer true that only feature or supplement pages should utilize white space; even news pages benefit from more breathing room. I incorporate white space in all pages of my projects, and at some level, the reader appreciates it.

Beside the obvious, there are many places to employ white space:

- Between lines of headlines or summaries

- Between photographs and captions

- Between subheads and the text that follows them

- Between a graphic and surrounding elements

- Around the box that packages a story or photo essay

- Directly under the header of the page (two lines of white space recommended here)

- Between ad space and editorial space

White space is the most silent of aids to the designer. ■

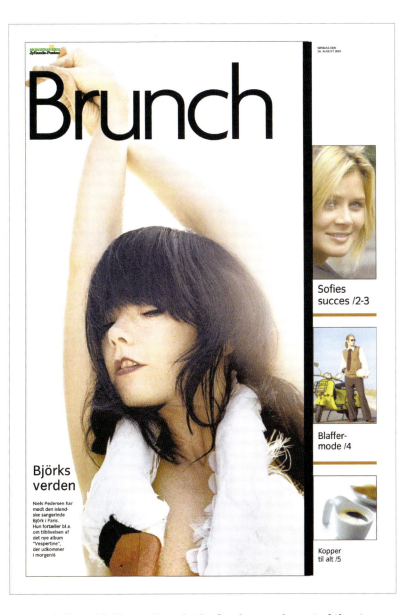

Forceful silence: *Brunch,* the Sunday supplement of the *Jyllands Posten* in Copenhagen, emphasizes big photographs and long text, and buffers it all with generous white space. If they weren't cushioned by white space, the pieces would be less inviting.

The power of white: When Miller Media redesigned Barra's website, simplicity was the goal. Barra, a maker of complex risk-management tools, was scaring off users with an information-dense site. Designers spent the majority of time working with editors to whittle down the information to the essentials, then applied a clean, open design with white space at a premium.

Less is more: During a change in editors, Miller Media was asked to update the look and feel of *House Beautiful,* an interior design magazine that had seen market share slipping. Lead designer John Miller stripped down the stuffy covers, concentrating on simple, iconic images. The logo was redone in a classic serif; typography was elevated to starker, more elegant levels. And to complete the look, liberal amounts of white space were used on every page.

Culture and design

Design is deeply rooted in the culture and traditions of the people for whom it is intended. Furniture designers, sculptors, and architects follow subtle, cultural leads in their work. Publication design is no exception. Around the world, newspapers and magazines look alike, but I am even more surprised by the differences, usually accentuated with touches that are not so obvious, but which are there, waiting to be discovered. Scandinavian newspapers tend to have the clean, uncontested look that is typical of Nordic cities.

Deciphering cultural elements takes nothing more than a quick run or walk through the city, or a sharp eye when traveling by train or bus within a city. Newspapers in those Nordic cities with Viking traditions circulate in environments where one does not see curtains in any color but white. However, try a tour of a Latin American city, or Greece, Spain, and Italy, and the opposite is true. White curtains rarely appear; instead, one sees every color of the rainbow. That is when the designer takes out the digital camera, or the notepad, and scribbles thoughts at the most basic level of how culture and design blend.

Latin American newspapers show more emotion, bolder headlines, brighter colors. Greek and Italian newspapers also display the immensity and intensity of life in those countries.

In American newspapers, regional differences are accentuated: with southern newspapers showing a calmer, more relaxed visual environment than those in the large cities of the Northeast and Midwest.

An important step in the design of a newspaper is to incorporate a bit of cultural identity. ∎

www.dnoticias.pt MADEIRA TERÇA-FEIRA, 28 DE MAIO DE 2002 PREÇO 0,50€ (IVA incl.)

DIÁRIO de Notícias

EDIÇÃO: JOSÉ SETTENBENT DA CÂMARA ANO CXLI · N° 9363 / DIÁRIO MAIS ÚTIL INDEPENDENTE

/ PÁGINA 22 / MAR /
Porto Santo vai acolher regata com 100 iates

/ PÁGINA 21 / ECONOMIA /
Air Luxor prevê atingir 70 voos semanais

/ PÁGINA 32/ ÚLTIMA /
"Encontro de Gerações" desperta autoridades

/ PÁGINA 7/ REGIONAL /

Pensões sociais custam 183 milhões

Verbas para o subsídio de velhice batem as despendidas com o apoio familiar

No ano transacto, o subsídio familiar a crianças e jovens contemplou 29.633 beneficiários, enquanto o subsídio de desemprego foi pago a 4.267 pessoas, menos que em anos anteriores dada a redução da taxa de desemprego na Madeira.

No ano 2001, o Centro de Segurança Social da Madeira pagou, em prestações sociais, mais de 183 milhões de euros, ou seja mais de 36 milhões de contos. Um valor que abrangeu um total de 93.936 beneficiários e pensionistas. Destes, 34.224 auferiram pensões de velhos, 7.312 pensões de invalidez, e 16.500 pensões de sobrevivência.

/ PÁGINA 6 / REGIONAL /

Governo muda actuação das juntas médicas

Estudante mantém equipa suspensa

NESTA » EDIÇÃO

1 actual **2** casos do dia **3** regional **4** regional

1-CINM: *PS desafia Governo* / Páginas 2 e 3 2-Câmara de Lobos: *Polícia prende dois* / Página 20 3-Advogados: *Sequeira promove LAIA* / Página 8 4-Pedreira dá polémica: *DRCI "lava as mãos"* / Página 12

Accentuating the natural: Newspapers must reflect the visual environments in which they exist. Here we see front pages that typify their regions well. *Il Secolo XIX*, Genoa: Italian newspapers show energy, congestion, vibrancy. *Diario de Notícias*, Madeira, Portugal: An island of colorful flowers, a front page to match. *Typos*, Athens, Greece: Vigorous, bold, expressive.

White on black

From time to time one sees effective use of white type reversed over a black background. Some purists of design hate the technique; it is even banned in some newsrooms.

There is no substitute for the legibility of black type over a white background. That said, it is also true that white type over a black background can look sharp, raise the presence of a quote or highlight on a page, and add a visual to a page where there might be none.

Like all other tools available to the designer, reverses work best when used in small sizes. A very large box going from the top to the bottom of the page, all black, with a long article set in white over it, will not be legible. In fact, it will look hard to penetrate, and few will enter it. But used in small versions, and not repeatedly, it can be another efficient way to offer contrast and hierarchy for an item on a page. ■

Three-dimensional motion: This inside page from a proposed Spanish daily edition for The *Dallas Morning News* shows the power of a headline set in white against a black background.

Case Study |
GarciaMedia.com

The challenge: With our own website we wanted to create something simple, but with a great amount of information. We wanted our site to be informative, interesting, and resourceful—and less about us. As a design firm, we knew we had to have a very visually appealing site, but as educators and journalists we also realized we had a good amount of content that could be useful to visitors. To concentrate only on visuals would have given us more creative freedom in our design, but we knew that ultimately the look would have to be driven by the content—not the other way around. We're about content design. For us the content comes first, so it makes sense to have the site be full of rich, easily navigable content.

garcia.media

the newspaper redesign

10 questions to ask
before a redesign

NEWS

HOME

ABOUT US

SERVICES

CLIENTS

CASE STUDIES

RESOURCES

NEWS

CONTACT US

Search

Live newspaper
front pages online

Check out Creative
Director Ron Reason's
page of links to live
daily page designs
online, posted daily as
JPGs or PDFs.
Submit your own
newspaper front page!

Small Newspaper
Resource Center

Garcia Media has
expanded to serve
smaller newspapers
and weeklies. For
helpful advice and
insights, click here.

Training Programs

Garcia Media is not
just about redesign.
We offer unique
consulting services in
staff training,
leadership
development, and
strategic
reorganization. To
learn more,
visit our list of
programs.

The Evolution of THE WALL STREET JOURNAL

1889. The first Wall Street Journal.

1935-1945. "What's News" column added.

2002. "Today's" Wall Street Journal.

July 8, 1889 - The first Wall Street Journal is published. It contains 4 pages and sells for 2 cents.

1902- Clarence Barron buys Dow Jones & Company, the publishers of The Wall Street Journal. More than 100 years later, his heirs retain a controlling interest in the company.

1930s - The Review and Outlook column from page one is moved and established on page eight to create a true editorial page. During the Depression years, the pages of the Journal are enlivened with new, light columns, short features and typographical brighteners.

1935-1945 - Casey Hogate begins a series of changes that ultimately result in the metamorphosis of The Wall Street Journal into a new kind of daily newspaper. Barney Kilgore, the creator of the modern Wall Street Journal, adds first the "Washington Wire" and then later the "What's News" columns that continues to characterize page one of the Journal, as he creates a national business newspaper for people from "Portland, Maine to Portland, Oregon." A-heds, which also appear on the Journal's front page, are developed by Kilgore's successor, William Kerby. By 1942, the design of the front page is solidified, remaining relatively unchanged until April 9, 2002.

1947 - The Journal wins its first Pulitzer Prize, for editorials by William Henry Grimes.

1966 - The Wall Street Journal passes one million circulation for the first time.

1977 - The Journal begins selling more copies each day in California than New York, as it does to this day.

1979 - The Journal becomes the largest paid-circulation newspaper in America.

1980 - Money & Investing becomes the Journal's second section.

1988- The Marketplace section debuts, as the Journal moves to a three-section format.

1998 - Weekend Journal begins publication as a Friday fourth section.

2001 - The Journal wins its 24th and 25th Pulitzer prizes, for International Reporting by Ian Johnson on Falun Gong and for Commentary by Dorothy Rabinowitz.

April 9, 2002 - Today's Wall Street Journal

What we did:

We started with a thorough inventory of the content, broken into categories and written for the Web. When we were tempted to "keep it short," we listened to the research that people actually read more online. (Put lengthy text in print and it's avoided like an insurance seminar, but put it online and you have a captive audience.) Now the real challenge began: cramming everything in a design that followed our philosophy: keep it simple.

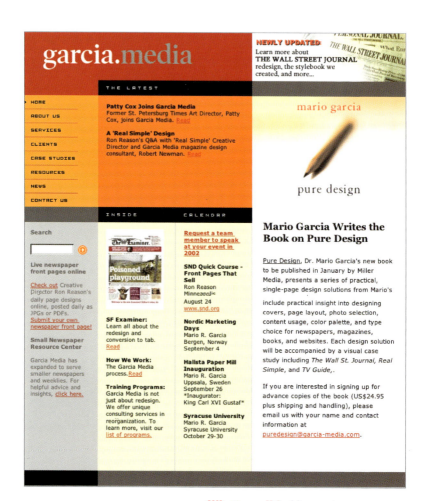

What we did: After a dozen or so failed sketches, one of our designers, Mignon Khargie, presented an "oh by the way" design she thought of at the last minute. That design is what you see on our site today. Mignon did not design a website, she designed our information, using headlines and photos as main images.

What we did:

When it came to color, Garcia Media chose a palette of bold, striking colors to establish an instantly recognizable brand. With online colors there is a fixed palette and different representations of those colors on different browsers or plat-forms (Windows and Macs, for example). We tested colors that would be great on screens regardless of different computers or browsers. We also wanted a combination of unique colors, the kind that couldn't be described using traditional color names, like red or blue. We wanted colors that were Garcia Media colors and that can only be described that way. As Mario Garcia Jr. explains: "When we work on a site, color is one of the last decisions we make. For us, it's not about decoration. We want someone to be able to walk by a computer, see a page from the site and know it is ours. We brand with color."

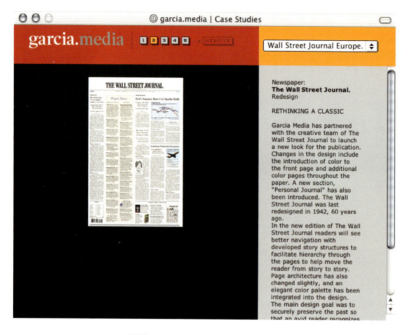

What we did: For the case studies and bios of team members we chose a pop-up format, which is easy to navigate and allow the user quick access to the page they came from. Web tracking shows that users prefer pop-ups for multiple, small chunks of material. We kept them simple, so they had the same design and architecture branding them to the main site, despite different navigation.

What we did:
For listings like the Clients page we used shades of colors to avoid long columns of text, making the lists more readable.

pictures

HOW TO USE IMAGES

Photo composites

It is fashionable these days for newspaper designers to display "photo composites" on their pages. This is not a bad idea, and it's actually not a new one. Publications during the 1950s displayed many groupings of photographs in order to maximize photo usage within a limited space. During the 1970s, the big picture era was upon us, and photo composites became a rarity. But they are back.

Photo composites work best for groupings of images that tell a story, but they should *never* be a substitute for selecting *one* image that really tells the story. For example, in staple news coverage, such as of fires, accidents, plane crashes, and so on, using one dominant image is still better than putting five smaller images together within a rectangle. Photo editing is exactly what the name implies: someone editing from a field of many images, and coming up with the definitive one to tell the story. On the other hand, if one is illustrating the offerings in a museum that just opened, or describing pieces that are part of an ensemble in a fashion article, composites may be the best solution.

Remember: when designing photo composites, avoid splitting the rectangular area into equal units; a kind of Mondrian architecture, with pieces in various sizes (some horizontal, some vertical) works best. And divide the photos with a four-point rule. Also, composites work better in color, where contrast stands out, than they do in black and white, where, if printing is not good, the images blend into a muddy surface. ■

Page one

Newspaper front pages are not to be studied. They are to be reacted to. Magazine covers should not contain complex "concept photos" that readers have to struggle over to understand. The amount of time readers give to page one before deciding on their reaction has become shorter and shorter. To pass the "kiosk" or "coffee table" test, therefore, a publication's front page must have strong visual impact, which 99 percent of the time depends on a good photograph.

- The number-one problem with most front pages is lethargic, passive photographs.

- At the same time, page one is not a gallery for artsy photography. It is a venue for the best photo of the day, one that conveys a story or two, creates an emotion, pulls readers in, and makes them read.

- Page one photos should be active, surprising, and, whenever possible, show people. This is not the place for a still view of the beautiful Alhambra, unless world leaders are seen meeting there.

- Especially in magazines, cover photos should be iconic, graphic, not overly complicated.

- With few exceptions, page one is also not the place for gigantic infographics, which require that the reader study their contents. Infographics are one of the great storytelling techniques a newspaper editor can use, but they are best on inside pages. ■

Impacting through photography: The front page of the *San Jose Mercury News* excels in its use of large, dominant photos to attract readers. By contrast, the headlines surrounding the photo tend to be smaller so as not to compete with the visual impact of the photograph.

Icons: Covers, whether on a book, magazine, or newspaper, need to be simple and iconic. For the *Vanity Fair* and *Legends* covers, John Miller chose images that were simple and stark, then cropped tightly to give a feeling of immediacy. Garcia Media employed the same iconic look for *Momentum,* the employee magazine for MAN Roland in Hamburg, Germany.

Stand-alone photographs

We all like stories accompanied by good photos. Editors and designers everywhere try hard to find that one "visual" that fits perfectly with the text. Sometimes it does not happen.

That is when we appeal to our next-best solution: the stand-alone photo. In today's environment, with readers sweeping rapidly through the pages of the newspaper, stand-alone photos are a quick way to provide good graphic impact on the page. Many stories can and should be told only through photos. Brief texts do the job.

Stand-alones can also serve as navigational devices. A stand-alone a sports event on page one may capture our attention, and refer us to a complete story inside. Here are some tips on how to best use stand-alone photos:

- Place a good headline over the photo (the headline can also appear below the photo, but I always recommend the superior position for more effective packaging).

- Box or rule the photo, headline, and caption, to guarantee that the stand-alone photo does not "float" on the page or appear to be related to stories around it.

- Never write a block of text under a stand-alone photo that is deeper than the photograph. Captions of six to nine lines are ideal. Otherwise, write a story. ■

Pictures tell a story: The *Las Vegas Review Journal* uses a stand-alone photograph to tell the story without resorting to the traditional headline and text combination. Readers who scan headlines and look at photos enjoy this type of treatment, as they get information without having to read much text. Stand-alone photos can be used to lead readers to an inside page where the story develops further, or they can offer enough information in the caption itself.

Center of visual impact

One of the most frequent problems with newspaper front pages is the lack of a center of visual impact, or CVI.

It does not take an art director to know that one photograph or illustration needs to be three times bigger than any other on the page to provide that much-needed visual entrance. A CVI is essential and is the simplest formula to guarantee a sense of proportion and balance, and to ensure design success.

The CVI can appear anywhere on the page. However, in the case of the front page, it should be as high as possible, especially for pages that are folded while displayed in newsstands, store shelves, or on the kitchen table.

In a perfect world the lead photo would be related to the lead article. When this is not possible, the CVI can refer readers to a significant article inside the newspaper.

As more newspapers move to narrower page sizes, more pages are appearing without a distinctive CVI. But no matter how small a page is—even in the case of A4 formats—designers must commit to one dominant image. ■

EL TIEMPO
MARTES 16 DE JULIO DE 2002

CULTURA
**DEBATES
DE LA CUMBRE**
En la Reunión de Ministros se
discutieron la promoción del
libro y la relación entre
cultura y comercio. 2-6

GENTE
**'UNA IDEA LOCA
HECHA REALIDAD'**
Elsa Patricia Bohórquez
lideró el proyecto de
recuperación urbana
de El Cartucho. 2-12

2

DEPORTES
**NUEVO REFUERZO
PARA MILLOS**
El volante vallecaucano
Mayer Candelo es la octava
contratación del
equipo embajador. 2-4

TOUR / DESDE 1999, LANCE ARMSTRONG NO PERDÍA EN UNA CONTRARRELOJ INDIVIDUAL

La corrida de
BOTERO

Santiago Botero se
convirtió en el primer
colombiano que
gana una 'crono'
individual en el
Tour de Francia.

CONTRARRELOJ

Histórico
ganador

ESTO DIJO...

Santiago Botero
Corredor del Kelme

*'Lo que
más me
alegra es
poder
darle un
poco de
moral a mi país. Es muy
importante un triunfo
en un acontecimiento
como este. Sé que hay un
gran seguimiento y que
todas están pendientes
de mi. Primero me
quiero probar en los
Pirineos para ver cómo
estoy. Espero tener
buenas sensaciones en la
montaña.'*

DEPORTES

Santiago Botero consi-
guió lo que muchos han
intentado y nadie había
logrado: batir al gran
Lance Armstrong en
una contrarreloj indivi-
dual de larga distancia
en el Tour de Francia,
la modalidad en la que
no tenía rivales y do-
minaba desde 1999.

Ayer, Botero terminó
con la hegemonía de
Armstrong al recorrer 11
segundos más rápido los
52 kilómetros que separan
a Lanester de Lorient. 'Le
gané por poco y el sigue con sus
mismas opciones, pero esto es
bueno para el espectáculo y el
colorido al Tour', dijo.

El colombiano registró
un tiempo de una hora,
dos minutos y 18 segun-
dos y por segunda vez
en su carrera obtuvo
una victoria de etapa en
el Tour. Ahora, es quinto
en la general (recuperó
21 puestos) a 1m 55s del
líder, Igor González de
Galdeano.

En el kilómetro 19,5
primer punto de crono-
metraje, Botero aventajaba
en 3 segundos al líder y en 4 a
Armstrong. Pero el mejor tiem-
po era para Sergei Honchar, con
24m 40s. En el 35, el panorama
cambió. Honchar pasó al tercer
lugar, Botero se afianzaba como
el mejor del día y Armstrong
igualaba el tiempo del corredor
del Kelme (42m 16s).

En el último trayecto, Bo-
tero dio su mejor demostra-
ción de fuerza y, al final, le
sacó una ventaja de 11 se-
gundos a Armstrong, de 18
a Honchar y de 19 al líder.
'Cumplí un sueño a pesar
de que dudaba si podría ga-
nar mi primera contrarre-
loj en el Tour', declaró des-
pués de la histórica victoria.

**LOS PIRINEOS
ESTÁN CERCA**

El jueves aparecen los Piri-
neos, con las dos primeras
etapas de alta montaña. La
primera entre Pau y La Mon-
gie sobre 158 kilómetros, con
un premio fuera de categoría
y otro de primera en la meta.
El viernes la jornada será más
dura, con dos premios de se-
gunda categoría, dos de pri-
mera y otro fuera de catego-
ría en el arribo en Plateau de
Beille, después de recorrer
199 kilómetros.

Las etapas contrarre-
loj se han convertido en
la especialidad de San-
tiago Botero.

En la Vuelta a España
del 2001, ganó dos etapas
contra el cronómetro. La
primera fue el 14 de sep-
tiembre en Torrelavega, so-
bre 44,2 kilómetros, donde
impuso un tiempo de 54 mi-
nutos y 9 segundos. En la úl-
tima etapa, en Madrid, vol-
vió a repetir. Esa vez, sobre
35 kilómetros planos y con un
tiempo de 43m 35s, derrotó a
Levy Leipheimer que fue se-
gundo y a Ángel Casero, quien
ganó de la Vuelta.

El año anterior, logró el
bronce en la especialidad con-
tra el crono, en el campeona-
to del mundo. El 12 de junio
pasado, Botero ganó la
contrarreloj indivi-
dual de la Dauphiné
Liberé al parar el
cronómetro en 52m
30s, luego de reco-
rrer 41 kilómetros.
Armstrong tardó 49
segundos más que el
colombiano.

Los únicos dos an-
tecedentes de colom-
bianos ganadores de
etapas contrarreloj
fueron Álvaro Mejía,
en la Dauphiné Liberé de 1990 en
Annecy, y Víctor Hugo Peña, en
el Giro de Italia del 2000, en la eta-
pa entre Lignano y Bibione.

ESTO DIJO...

Lance Armstrong
Corredor del US Postal

*'He rodado
bien. Botero
es un
especia-
lista, un
habitual de
las 'cronos'. En la
Dauphiné, la distancia
fue mayor entre nosotros.
Diez a once segundos
en 52 kilómetros, son
muy poco'.*

POSICIONES

Novena etapa: 1. Santiago Bote-
ro (Colombia/Kelme) 1h 2m 18s.
2. Lance Armstrong (USA/USP) a
12s. 3. Serhiy Honchar (UKR/FAS)
a 18s. 4. Igor González de Galde-
ano (ESP/ONCE) a 19s. 5. Levaño
Bodrogi (HUN/MAP) a 25s. 6.
Raimundus Rumsas (LTU/LAM)
m't. 7. David Millar (GBR/COF) a
50s. 18. Víctor Hugo Peña (Co-
lombia/US Postal) a 2m 14s.

Clasificación general: 1. Igor
González de Galdeano (ESP/ON-
CE) 33h 21m 23s. 2. Lance Arms-
trong (USA/USP) a 26s. 3. Josep-
ba Beloki (ESP/ONCE) a 1m 23s.
4. Serhiy Honchar (UKR/FAS) a
1m 35s. 5. Santiago Botero (Co-
lombia/Kelme) a 1m 55s. 6. An-
drea Perun (ITA/CST) a 2m 8s. 7.
David Millar (GBR/COF) a 2m 31s.
96. Víctor Hugo Peña a 13m 38 s.

BOTERO Y ARMSTRONG

SANTIAGO
BOTERO

Lance Armstrong no perdía una contra
reloj en el Tour desde 1999, un costal los
prólogos que ganaron David Millar y Chris-
tophe Moreau en 2000 y 2001. En la pre-
sente temporada ya cedió ante Igor
González y Santiago Botero en la Midi
Libre y Dauphiné Liberé. Ayer, en Lorient se
llevó el tercer disgusto del año. Por su parte,
Botero, de 29 años de edad, obtuvo su se-
gunda etapa en el Tour, tras la lograda
hace dos años en Briancon.

LANCE
ARMSTRONG

IGLESIA / SI NO DESISTEN DE SUS VOTOS, SERÁN EXCOMULGADAS

VIDA DE HOY

Las ordenadas, llamadas al orden

En el derecho canónico, la ex-
comunión sólo puede dictarse
por pérdida de fe, herejía
(inconformidad con el dogma ca-
tólico), escisión de la Iglesia
(rompimiento o división), viola-
ción del secreto de la confesión,
aborto y violencia física contra
el Papa.

Y según las siete mujeres or-
denadas sacerdotisas el pasado
29 de junio, en Austria, por el
obispo carismático argentino
Rómulo Braschi, no han violado
ningún punto.

"No hemos cometido críme-
nes ni herejías, tampoco hemos

roto la fe ni desertado de ella. No
hay motivos para excomulgar-
nos", afirmaron Gisela Forster y
Christine Mayr-Lumetzberger,
dos de las nuevas sacerdotisas.

En la sede de la Iglesia católi-
ca apostólica carismática Jesús
Rey, de Viena (Austria), las sa-
cerdotisas se reunieron la sema-
na pasada con los medios para
expresar sus opiniones, mien-
tras el Vaticano hacía lo propio
argumentando que tienen plazo
hasta el 22 de julio para que de-
claren la nulidad de las órdenes
recibidas.

Las mujeres, nacidas en Esta-
dos Unidos (tres), Alemania
(tres) y Austria (una), no darán
su brazo a torcer. Y el Vaticano
tampoco. Para este último, Ch-
ristine Mayr-Lumetzberger,
Adelinde Theresia Roitinger,
Gisela Forster, Iris Müller, Ida
Raming, Pia Brunner y Angela
White no pueden ejercer el mi-
nisterio en ningún lugar.

Las razones de la Iglesia no
son nuevas. Cuando a principios
de los años 70 la Iglesia Anglica-
na sugirió ordenar sacerdotisas,
el papa Pablo VI argumentó que

esto era imposible porque está
"consignado en las Escrituras
que Cristo escogió sus apóstoles
entre varones (...) reclayendo a
las mujeres del sacerdocio para
estar en armonía con el plan de
Dios para su Iglesia".

Y el papa Juan Pablo II, en su
Carta Apostólica Ordinatio Sa-
cerdotalis, afirma que la Iglesia
"no tiene la facultad de conferir
la ordenación a las mujeres"

De este modo, "la ordenación
realizada es la simulación de un
sacramento, y por ello resulta in-
válida, constituyendo un grave

delito contra la Iglesia y su uni-
dad", dice el documento expedido
por la Congregación para la Doc-
trina de la Fe, del Vaticano.

En opinión del sacerdote Ber-
nardo Escobar, rector del Semi-
nario Diocesano de Palmira (Va-
lle), la excomunión es un poco
exagerada. "No se trata de un pro-
blema de herejía sino de indisci-
plina. Lo peligroso es que esto lle-
ve a un cisma de la Iglesia", sigue.

Por lo pronto, la Iglesia no mo-
dificará sus normas. "La tradi-
ción es esa y sólo a través de un
concilio ecuménico podría plan-
tearse la ordenación femenina",
dice el padre Escobar. Hay 2.000
años de masculinidad difíciles
de cambiar.

Photography vs. illustration

One of the most difficult decisions to make is how to illustrate a story. As always, the basic question should be: What is the best way to tell the story? Many times, in news events, photographs are usually the answer. A photograph conveys emotion and information and advances the storytelling process in a direct way that impacts the readers and draws them into the story.

However, illustrations can be the ideal visual image in stories that are more abstract, or where a photograph may be risky to use. Lifestyle articles, for example, can benefit from the impact of an illustration that captures the spirit of the story. Illustrations are ideal for subjects such as abortion, divorce, and the death penalty, to mention a few. Visuals need to reflect the point of view and tone of the stories they accompany. Photos for the stories above may be difficult to find; illustrations can be made to order, conveying the necessary mood. Illustrations can also be effective when one does a long interview or reportage with a well-known individual whose photos are overused; an illustration, caricature, or sketch of the person can help to create greater interest, while providing the visual surprise of an image we have not seen dozens of times before.

Often, good designers mix photos and illustrations, with great results. Pure design relies on the instinct of the designer, working in close cooperation with the editor or reporter to seek the best visual to illustrate the story. ■

Photo and illustration: The artists and designers of *La Gaceta*, of Tucuman, Argentina excel in their ability to create a visual concept for a story and develop it, in a relatively short period of time. Here we see how an entertainment section is illustrated with a photograph, making this page visually seductive and appealing. Sometimes, as in this case, using both a photograph and an illustration is most effective.

Infographics speak volumes

Busy readers appreciate good, simple informational graphics that visually tell them a story.

Good infographics are based on the purist design strategies: they are clean and they are focused on just a few ideas. The best ones are small and concentrate on basic information, without attempting to be too textbook-like or encyclopedic in approach. A complicated graphic defies its purpose.

Here are some tips, as recommended by infographics specialist Jeff Goertzen, whose award-winning infographic work has appeared in newspapers throughout the world:

- Start planning early for successful graphic presentation. Get ideas down on paper soon, probably right after the reporter/artist. What is the aim of the graphic? What is it supposed to communicate to the reader? If the graphic accompanies a story, how does it enhance the storytelling process?

- Research the content of the graphic, taking into account that sometimes readers will look at a graphic before they read the story accompanying it. Those designing a graphic should ask editors and reporters for leads, set up interviews with reliable sources, consult websites, and take photos to use as factual visual data. Research is the key to a graphic that communicates in an authoritative manner.

- Have reporters and editors proofread the first possible draft of it.

- Write a good headline, remembering not to repeat what the headline of the story says. Use the opportunity to enhance another level of the storytelling process.

Ultimately, a good infographic should be visually aesthetic. Readers enter a graphic to get information, but it is visual appeal that leads them to it first. Content comes first, visuals come second. The combination of the two, plus effective research, makes the best infographics. ■

Transmeta expands its horizons.

By Elizabeth Lamb

After first aiming its low-powered chips at the laptop market, Transmeta has a new target: servers. As Justin Higgard reports on page 30, Transmeta is well positioned for the burgeoning rack server market because its chips consume far less poser than competing products. After first aiming its low-powered chips at the laptop market. Transmeta has a new target: servers. As Justin Higgard reports on page 30, Transmeta is well positioned for the burgeoning rack server market because its chips consume far less

poser than competing products. After first aiming its low-powered chips at the laptop market. Transmeta is well positioned for the burgeoning rack server market because its chips consume far less poser than competing products. After first aiming its low-powered chips at the laptop market. After first aiming its low-powered chips at the laptop market. Transmeta is well positioned for the burgeoning rack server market because its chips consume far less poser than competing products. After first aiming its low-powered chips at the laptop market.

25%

In the next three years, Transmeta, with its new chip, is expected to take 25% of the notebook computer market.

VC Investments

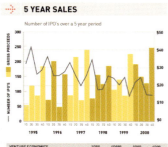

Number of IPO's over a 5 year period

1995 1996 1997 1998 1999 2000

VENTURE ECONOMICS	1Q99	4Q999	1Q00	4Q00
Net VC raised	$3.3	$13.0	$15.9	$10.6
Net Fundings	360	841	953	639
Average funding round	$9.2	$9.2	$9.2	$9.2
Total VC raised	$4.9	$4.9	$4.9	$4.9
Net VC's portion of total funding	68%	84%	86%	81%

VENTURE ECONOMICS	1Q99	4Q999	1Q00	4Q00
Net VC raised	$3.3	$13.0	$15.9	$10.6
Net Fundings	360	841	953	639
Average funding round	$9.2	$9.2	$9.2	$9.2
Total VC raised	$4.9	$4.9	$4.9	$4.9
Net VC's portion of total funding	68%	84%	86%	81%

DOLLAR AMOUNTS IN BILLIONS. SOURCE: FORRESTER RESEARCH

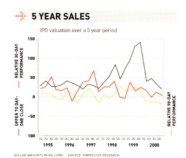

IPO valuation over a 5 year period

1995 1996 1997 1998 1999 2000

DOLLAR AMOUNTS IN BILLIONS. SOURCE: FORRESTER RESEARCH

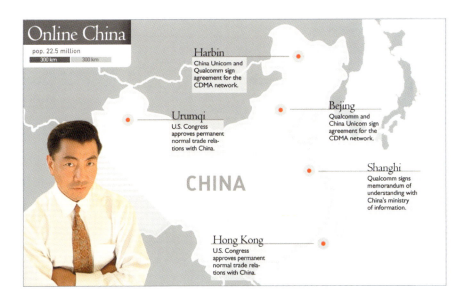

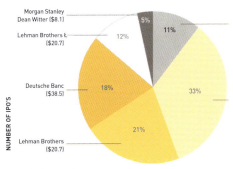

Morgan Stanley
Dean Witter ($8.1) 5% 11%

Lehman Brothers E
($20.7) 12%

Deutsche Banc 18% 33%
($38.5)

NUMBER OF IPO'S 21%

Lehman Brothers
($20.7)

LOAN DEBT (MILLIONS)

Charts, bars, and maps: When John Miller and Aaron Kenedi redesign any new magazine, strongly branded infographics are always a primary focus. Often they work with specialists, such as artist Stephanie Heald, to develop simple, pared-down charts and graphs that are effective storytelling tools and help extend the publication's brand.

Head shots

Head shots were among the first uses of photography when newspapers began publishing photos. They provided a quick visual reference to people mentioned or quoted in stories. To this day, they remain favorites.

When you take a sample of a newspaper or magazine to a focus group, it does not take a specialized eye-tracking computer to see how the eyes rest on and read the head shots.

They are quick encyclopedic references to who is in the story. Like headlines—and sometimes even more so than headlines—head shots alert readers to the "what" of the story.

In addition, head shots require little space, become unobtrusive in the overall look of the page, and create energy without overpowering the elements around them.

Here are some tips for the use of head shots:

- Use them small, and create a template, so that all head shots throughout the entire publication are the exact same size.

- Head shots should be closely cropped. The face is what is important. It's no use to let somebody's stomach show in what is meant to be a facial representation. By the same token, avoid the "passport" shot, in which it is difficult to identify the subject.

- Always use a caption, regardless of how well known the face may be. It is a matter of journalistic style.

- Head shots can be utilized within the text of a story, but also accompanied by a quote or highlight of the story.

- Head shots can be in black and white or in color. Readers like both.

- Head shots can be drawings as well as photos. The *Wall Street Journal* has a particular style for what it calls "head cuts." Images of people in the news do not appear as photos, but as pencil sketches. This renders the *WSJ*'s a unique style that is easily recognizable to habitual readers. ◼

Case Study | Real Simple

The Challenge: *Real Simple* is not your typical style magazine. The design needs to mirror the specific editorial philosophy of pure, elemental style. With his design, Robert Newman created a beacon of light and clarity in the midst of a world of clutter. It wasn't sensible to design a complicated, overly decorated page that describes how to unclutter a closet and thus one's life. Designers took cues from the title and the editorial. Specifically, *Real Simple* advances its design philosophy through three major areas: color use, white space, and the blending of words and images in the story-telling process.

What we did: The contents page typifies the approach at *Real Simple*. Newman describes the design: "Most contents pages serve as little more than reference tools for the editors who put out the publications. To us, the pages give the reader a sense of the magazine's interior design and mission over and above the information and data they deliver. And they aren't 'work' to look at."

What we did: Unique to *Real Simple* is an overall color palette, in both type and photographs, for each issue. Sometimes it's very prominent and other times it's subtle, and often it's related to season. For example, in an issue with a lot of photographs of blue sky and water, the designers opted for blue type and blue accents. The philosophy is to let the images and/or the content themes dictate color.

your 4 most vexing **storage**
problems:

solved

Chaotic cupboards, shoe-choked closets, seas of CDs, mountains
of mail—professional organizers say these are the most common
clutter problems. But you don't need to hire a pro to get your
life in order. For easy, affordable fixes for your **kitchen, bedroom,**
living room, and **home office,** just turn the page

PRODUCED BY KELLY TAGORE
AND LINDA ROTHSCHILD
PHOTOGRAPHS BY PAUL WHICHELOE
OPENING PHOTOGRAPHY BY WILLIAM WALDRON

(before)

QUICK
CHANGES
Easy room makeover ideas from $30 to $350

Blank walls and a blah color scheme got you down? No money to redecorate? No problem. Here are a dozen ideas for **adding color and creativity** to walls, windows, and everything in between that take more courage than cash

PRODUCED BY KELLY TAGORE
PHOTOGRAPHS BY BOB HIEMSTRA

(after)

What we did: Perhaps more than in any other magazine, white space reinforces the simplicity and organization that embodies *Real Simple*. One can say that white space actually plays a protagonistic role at the magazine, blocking the page, separating articles, or allowing for breathing room around a powerful photo. White space is considered a part of the color palette, a way of expressing cleanness, simplicity, and authority.

182

REAL SIMPLE

life/home/**body**/soul

6 delicious one-dish dinners

Quick fixes:
22 ways
to **control**
your life

An easy **diet**
game plan:
a pullout guide

Clutter-free
kitchen

Chocolates
we love

Lazy-day
clothes

Ageless
hands

FEBRUARY 2002
$3.50 US $4.50 CAN
www.realsimple.com
AOL keyword: real simple

> When I don't have to start dinner from scratch, I have more time for myself at the other end of the night.

MAKE DINNER FROM THE FREEZER

REAL SIMPLE

life/home/body/soul

Easy storage solutions for every room

Quick weeknight recipes

Get fit faster

Supermarket shortcuts

Beating the blues

The best jeans for you

Balancing love and work

MARCH 2002

184

What we did: At *Real Simple*, stories are told through words as much as pictures. The editors know that some stories must be long to convey many ideas, tips, and descriptions. However, the designers and editors work to change some long running narrative text into sidebars, or sidebars into running text. Simply because a text is long does not mean that it must be cut. It can be redistributed as second readings, leaving the narrative as the main element.

process

Good briefings

The best way to kick off a redesign project, or the creation of a new publication, is through a thorough briefing.

A good briefing is that rare chance to gather key members of the group who will be in charge of creating the new design, and to get them around the table to present ideas.

Briefings, even though they should be free-form meetings, must begin with an outline of what goals to achieve. I have always maintained that all projects begin with a sort of "fantasy" stage where one deals with what could be and abandons totally any discussion of restrictions on what can be done. Of course, all projects have a reality stage as well, but that comes much later.

In my experience, many projects that started with questions of "what if . . ." moved on to a higher level of innovation when those in the group answered with "why not?" Technical obstacles, human resources limitations, budget dilemmas, and deadline restrictions are all part of the reality that will raise its head soon enough during the course of a project, but to start with these as the basis of discussion is a wasted opportunity to be creative. Here are some tips for briefings that lead to innovation:

■ Gather a small group, or one manageable enough in size that it allows for the full participation of all.

- Start with an outline of goals to be accomplished: I emphasize the need to discuss the sunrise and sunset categories. What should we preserve? What should we eliminate? What new topics need to be included?

- Deal with philosophical discussions of what lies ahead. A redesign is not done for today, but more likely for the next five years in the life of the publication. Who will be its new potential readers? What target audiences are we trying to reach?

- Dream a little: consider a different format, a new color palette, new ways of telling stories, an original typographic font, or even a new logo. Briefings are the ideal stage for discussions of the impossible, which, in some instances, becomes reality.

- Bring to the table the organization's best and most innovative minds, regardless of titles or positions. ■

From workshop to prototype

Not all projects demand the same schedule or logistics. While a good foundation for organizing a redesign can be helpful, and we all have ours, sometimes the timetable and special circumstances demand a different approach, such as a three-day workshop where key people in a project gather, to discuss specific goals that can be accomplished by the end of the session.

This is where the value of the "workshop approach" to a redesign. In this style of operation, a group not to exceed twelve people gather in a room complete with computers, printers, and sketch pads. If the idea is to redesign a newspaper or magazine, then a top priority is to have content issues resolved prior to the start of the workshop.

On the first day, a half-session is devoted to a discussion of how the content will flow into the publication: scope and sequence.

This is followed by some sketching of how key pages—front page (cover), table of contents (navigators), inside pages with and without advertising, specific section fronts and supplements—will carry the look and feel that the content demands.

In a good workshop setting, there is more *doing* than *talking* As soon as some basic ideas have been exchanged, the next step is to sit at the

computers to produce very primitive sketches that are then printed and put on display or beamed onto a projection screen for discussion. And what a difference it makes to deal with "real" pages, as opposed to abstract concepts. One hour of viewing pages can be the equivalent of weeks of discussing how a type strategy, column measurement, or color palette might look on a nonexistent page.

By the end of each day of the workshop, clean, approved sets of pages emerge.

And, at the end of the workshop, a full prototype of twelve or more pages are available, ready for designers and editors to carry into the next step, production of a full prototype to be printed and tested.

Workshops do more than just save time—they also provide a good opportunity for team building. Members of the workshop feel ownership of the project, and learning takes place that stays with each individual long after the project has developed wrinkles and everyone readies for the next workshop. ∎

Reader reaction

Many months of hard work suddenly pay off when that first edition of the newly redesign product—hits the stands. But it also puts editors on edge as the day of reckoning arrives. It is the day that readers will let us know how much they like or dislike what we have done.

This is an important part of the evolution of a redesign. And, no doubt about it, readers will let us know how they feel. Editors and especially publishers need to be prepared for the avalanche of negative calls that will come in first. Readers who like the redesign often have a second cup of coffee, admire their new paper, and go to work. Those who do not like what they see, or some small aspect of it, will get on the phone and fire off their complaints.

As a result, smart publishers plan for this, allowing members of the editorial staff to answer the phones and the emails, personally, reassuring readers and reminding them that the changes have been made to benefit the overall effectiveness of the publication.

Do not start redesigning when the first negative calls come in. This can be counterproductive, since many readers are basically reacting to change.

However, if a complaint persists two to three weeks after the redesign has been introduced, then there is reason to believe that it is a legitimate concern that needs to be addressed.

Gathering information from readers should be a continuous process, not just after the introduction of a new design.

This is one sure way to guarantee that the publication stays in tune with its readers. ■

Daily reviews

One way to maintain high levels of creativity is to conduct daily postmortems.

It never ceases to amaze me that designers and editors spend months creating a design strategy, but then do very little to evaluate how it works from day to day. This is what guarantees consistency, constant innovation, and, in the end, the longevity of the design.

This idea does not apply solely to the big postmortem after a redesign is introduced. In fact, the best publications I have ever worked with are those that implement a daily evaluation of what "we did yesterday" and how we can make it better today. Normally, in all of my visits, I engage in evaluations of the work done. I find that it is easier for editors and designers to accept criticism and comments from an outsider than from their peers. Internal reviews are sometimes hampered by the fact that the designer or editor whose work is evaluated may feel that the evaluator simply does not like him/her. The outside consultant is normally seen as an objective mediator, with authority, expertise, and no personal agendas.

Unfortunately, the consultant cannot be on the premises to perform evaluations, so each organization needs to motivate itself to schedule regular internal postmortems.

Here are some tips for conducting effective postmortems:

- Focus on a few items (do not attempt to review an entire magazine or four-section newspaper all at once!).

- Start with praise for work well done.

- Criticize work on the basis of what needs to be improved, without attacking the author personally.

- Always offer solutions when presenting problem areas.

- End the session on a high note, with comments about what works! ■

Listening to focus groups

Newspaper editors often ask what we think of focus groups and their effectiveness in providing answers to the many dilemmas that plague newsrooms. As one who has been involved in more behind-the-mirror focus groups than I care to remember, I always have one standard answer: focus groups will keep us from making at least one embarrassing mistake.

To that effect, I am a fan of them. That said, I also review focus groups without taking them too seriously. From each group, some consistent themes appear, and the redesigned product is better because of the conclusions reached.

Some things are almost universal in focus groups, as outlined here:

- The quality of the moderator determines the usefulness of the information gathered. It is important that the moderator be an objective, engaging, flexible person who will lead the discussion and drive it according to the conversation taking place in the room—rather than attempting to follow a prescribed set of prepared items that may not be of consequence to the participants.

- When it comes to testing a prototype for a redesigned product, approach the session with a few well-targeted segments to test, as opposed to an impossibly long list. For example, perhaps you

wish to know about the look and feel of page one, the legibility of body text, and the navigational system of a certain section(s). That should be enough for an intelligent conversation.

- When newspapers go from all black and white to color, it never fails that most readers will like the color but will also try to express how the color "takes away from the serious look" of their newspaper. This is to be expected, as well as the fact that the same readers will not even remember the black and white former style three weeks after the new color is introduced!

- Even when one tries to test purely graphic elements, readers are more interested in discussing content. This, I think, is good, even if it frustrates us when we want to know if a certain color screen works behind a column, and the readers concentrate totally on the content of the column.

Finally, all redesigned projects should include a focus group before final changes are made. It informs us about reactions. It guides us in perfecting details. Again, it keeps us from making that one embarrassing mistake that nobody in the redesign committee even thought about, but that one smart soccer mom spotted instantly, echoing feelings of perhaps hundreds of other readers. ■

Working with consultants

Most of the projects I have ever been involved in included highly skilled art directors in residence who were more than capable of leading the effort of a redesign. And, in some cases, the art directors themselves probably wondered why an outside consultant was needed, although, by the end of the process, most agreed they had benefited from the interaction and the learning involved.

In most cases, the consultant also learned much from the art directors and editors in the project. However, the role of the consultant has to be clearly defined and outlined at the beginning. Everyone has to know what his or her responsibilities and contributions will be to avoid misunderstandings later.

A redesign project is a major enough undertaking, with major obstacles to overcome, without also having to deal with personality problems.

What can the role of the consultant be?

- To define key points of the project: briefing, sketching, prototyping, researching, implementing

- To guide the designers through the sketching process with concepts that the designers can use to develop their initial ideas

- To guide designers and editors to resources that may prove helpful, from websites to books to other publications.

- To identify talents in the various areas needed in the redesign process: journalism, production, marketing, and advertising.

- To help with the creation of a stylebook

- To teach throughout the project. This is perhaps the consultant's most important role, that of nurturing the staff, imparting knowledge through seminars, discussions, and sessions in which the specific redesign project is momentarily put aside, talking about the craft, design, trends, and, in a sense, bringing the classroom into the newsroom.

- To foster team effort and to alert everyone to the benefits of working as a team: we all shine if the project wins. This is everyone's project, not anyone individual's creation.

When the art director and the consultant "click," everything else in the project falls into place quickly. Everyone benefits, but especially the readers, who gain from the experience and creativity of the team. ∎

ten myths of design

The myths

My diary entries contain travelogues, agendas, and occasionally, the graffiti of design myths. I always write these myths in red, to make sure I do not forget them. I must have more than 150 that I have listed during twenty years of traveling, but ten have become the "super myths," those that transcend nationalities, ethnicity, or language. I offer them as a checklist to see how many of them are part of your own myth repertoire:

1. Headlines should not be run next to each other.

"Bumping headlines" should be ranked as the number-one design myth, especially in the United States. I am certain that more time is spent in newsrooms everywhere designing pages that avoid headlines coming together than actually writing better headlines.

As a veteran of hundreds of focus groups that were shown pages with headlines that sometimes bumped, I have yet to hear a reader anywhere complain about them.

Of course, I am not an advocate of bumping headlines. However, I am suggesting that we should not spend unnecessary time and effort avoiding what seems to affect no one but the editor and his or her old journalism school professor.

2. Readers don't like reversed-out type.

Well, many editors don't. And I am sure that readers would probably find it unusual and hard to read if an entire article were set in white type against a black or color background. However, a few lines of a quote or a highlight set against a dark background will not affect legibility as long as the type size is larger than normal and the interline spacing is adequate.

3. Color must be introduced slowly.

Life is in color. Attempts at slowly introducing color in a newspaper that has been black and white for years are exaggerated. In this regard, one must respect the editors' knowledge of their own communities and their readers' ability to assimilate change.

However, my own experience has been that color is almost always extremely well received, and that readers in most communities no longer attach the label of "less serious" to newspapers that print in color. Specifically with twenty-five- to thirty-five-year-old readers, color is an expectation more than an abomination.

What is important, and this must be emphasized, is that color use be appropriate to the newspaper and its community.

4. Italics are difficult to read.

I have heard this at least five-hundred times, from South America to South Africa, and in Malaysia, too! Every editor seems to have a built-in catalog of anecdotes to illustrate why italics should never be used. They are supposed to be "feminine"; therefore, why use them in the macho sports section? They are "strange" to the reader and imply soft news, as opposed to hard news, so they should be relegated them to the gardening page. And, last, italics slow down the reading, so one should avoid using them in text.

The truth? Italics are unisex. A feature in sports can wear italics well, but so can that souffle story in the food section. The soft-versus-hard implication is an American phenomenon, I must admit. A banner headline in a strong italic font played large will do the job just as well as a Roman headline. Size and boldness and the distinction of the type used are more significant than whether the type is italic.

Contrast italics with roman type, or bolder or lighter type nearby, and they make that souffle rise on the page. Add them as a secondary line under a classic roman face, and there is music on the page. Give the name on the byline an italic touch, and somehow the visual rhythm of the text may be altered for the better.

5. Color and black-and-white photographs or graphics should not be mixed on the same page.

Never once have I heard a reader complain about this special cocktail of mixed black-and-white and color images. The designer's task is to select the best possible images, regardless of color, and display them properly on the page following a hierarchy that indicates where the eye should go first, second, and third. The color-versus-black-and-white issue becomes quite secondary to the content of the images, their placement on the page, and the role of the images in the overall design.

6. The flow of text should not be interrupted.

Magazines have been using quotes, highlights, and other text breakers for years. However, place one of these devices in the text of many newspapers, and you will find a chorus of editors repeating the same verse: any interruption of text causes the reader to stop reading.

I have found no evidence of this in the many focus groups I have observed or in the Poynter Institute's own Eye-Track Research. (Eye-Track scientifically documented how color, text, graphics, and photos direct a reader's eyes around a newspaper page.) Of course, interruptions can become obstacle courses if:

■ One places a twenty-four-line quote across 12 picas, forcing the reader to jump over text; or

■ One places the breaker in such a strategic position that the reader will not jump over it but will assume instead that he or she should move across to the adjacent column.

The length of the interruption and its placement determine legibility factors. Any interruption that requires more than a two-and-a-half-inch jump should be reconsidered.

7. Readers prefer justified type over ragged-right type.

The myth is that ragged-right type implies "soft" or feature material, while justified type represents serious hard news. This, too, is only in the minds of editors and some designers. There is no evidence of the truth of this perception. If newspapers had always set all their text ragged right, readers would have accepted that style.

Ragged-right type can change the rhythm on the page, even when used for short texts or for columnists. Its use incorporates white space, which is always needed, and allows for more appropriate letter spacing within and between words. Some research has confirmed that the presence of ragged right speeds up reading.

8. Story count counts.

One must have, says this myth, a minimum of five stories on the front page. Well, it is seven in some newspapers, and eleven in others. Story count is a state of mind; it should not be a formula. No two days in the news are alike for the editor putting together page one. On certain days, one big story may equal four, or even seven, small ones. Sometimes a photograph may carry the weight of ten stories, and so on. Individual elements are what count not a systematic formula that forces elements to satisfy a quota on the page.

What do we know about story count and page one?

Well, the front page is still the face of the newspaper and not only must display the day's news but also promote the best content inside. More is definitely better than less, and index items, promo boxes, and even stand-alone photos are all part of what makes the eye move. Readers in focus groups do not count stories.

Eye movement—activity on the canvas of the page - is what counts. How one makes the readers' eyes move can be determined by factors that are not necessarily associated with the mythical story counts to which editors are subjected.

9. Things should be left in the same place every day.

For many editors, a page one or a section front with static elements (promos at the top, left-hand column of briefs, and so forth.) provides a sort of teddy bear to embrace when they come to work every day. So, in typical fashion, editors always ask for the teddy bears.

There is no truth to the myth that readers want these elements exactly in the same places every day. I prefer to experiment with "teddy bears on roller skates"—letting the promo boxes appear differently from day to day. Some days use only one promo, some days use three. Surprise the reader with promos that run vertically on Tuesday but horizontally on Wednesday.

10. The lead story must always appear on the right-hand side of the page.

Editors seem sure of this, but nobody bothered to tell the readers. To them, the lead story is the one with the biggest and boldest headline, whether it is to the right or the left. Of course, hierarchy is important. No myth here. One definitive lead must appear on the page to guide the reader, but its appearance, as long as it is above the fold, becomes inconsequential.

Why the myths?

Well, what would newspapers be without them? Meetings would be shorter, and less argumentative, especially if there was no "italics"

myth. Who creates these myths? Like the games children play, nobody knows where these myths started. Children teach each other games in the schoolyard; professors pass on myths to their innocent charges in journalism school. Then those myths gain momentum when the rookie journalist hears the same myth glorified by his veteran editor, and so on.

What can one do about them? Select the ones you really want to do battle over, then wrestle the myth promoter to the ground.

Sometimes you win. ■

acknowledgments

I gratefully acknowledge all those who in some way or another contributed to the material that appears in this book. A multitude of talented people from design firms and publications all over the world were asked to participate and responded enthusiastically and often in record time. They include:

Pegie Stark Adam, Jay Anthony, Joachim Berner, Roger Black, Chas Brown, Kevin Burkett, Jose Camara, Javier Devilat, Joe Dizney, Felipe Edwards, Jonathan Falk, Sergio Fernandez, Christian Fortanet, Jay Friedlander, Ralph Gage, Ximena Garrido, Bob Gower, Stephanie Heald, Matt Mansfield, Bryan Monroe, Maurizio Nebbia, Gina Onativia, Carlo Perrone, Beiman Pinilla, Dave Pybas, Lars Pryds, Silva Raimundo, Claire Regan, Randy Stano, John Taylor, Tom Tozer, Eric Weidner, Ched Whitney, Mats Widebrandt, and Lisa Williams.